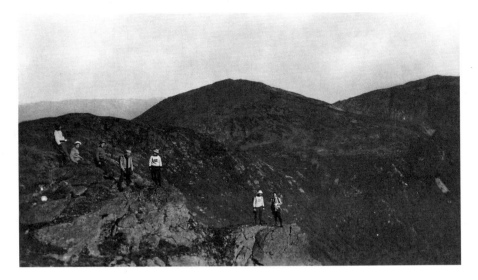

A tramping party of seven gathers at the head of the Great Gulf on its way toward the Northern Presidential Range peaks of Mounts Jefferson and Adams. *David Govatski.*

White Mountains
HIKING HISTORY

Trailblazers of the Granite State

Mike Dickerman

Charleston · London

Published by The History Press
Charleston, SC 29403
www.historypress.net

Copyright © 2013 by Mike Dickerman
All rights reserved

Cover photo on bottom of front by Chris Whiton.

First published 2013

Manufactured in the United States

ISBN 978.1.62619.080.1

Library of Congress CIP data applied for.

Notice: The information in this book is true and complete to the best of our knowledge. It is offered without guarantee on the part of the author or The History Press. The author and The History Press disclaim all liability in connection with the use of this book.

All rights reserved. No part of this book may be reproduced or transmitted in any form whatsoever without prior written permission from the publisher except in the case of brief quotations embodied in critical articles and reviews.

Contents

Preface	7
Acknowledgements	9
The Crawfords and Mount Washington	11
Path-Making in Franconia Notch and the White Mountains	25
The Historic Fabyan Bridle Path	37
Horseback Ascent of the Crawford Path	43
Allen Thompson: Early White Mountain Guide	51
The Trackless Zealand River Valley in 1879	57
Legacy of the North Woodstock Improvement Association	65
The History of Lost River and Kinsman Notch	75
Charles E. Lowe, Legendary Guide	89
The Goodriches of Waterville Valley	95
Compendium of Trail Guides and Builders	103
Bibliography	133
Index	137
About the Author	143

Preface

Over the last thirty or more years, as I've explored on foot nearly every corner of New Hampshire's White Mountains, I've gained a healthy respect for the individuals and organizations responsible for creating a trail system that now exceeds 1,400 miles and features more than five hundred different footpaths.

This book, with its varied chapters on early trail development and its profiles of the true trailblazers of White Mountain history, is, for lack of a better term, my thank-you card to the pioneer explorers and visionaries who saw in these mountains their unfailing beauty and their accessibility to all who wished to view them in an up close and personal nature.

About half the chapters you are about to read are pieces that I first penned five or six years ago when I began seriously researching the history of White Mountain trails. I have taken the liberty for this project to expand on these original works, and I hope that anyone who saw them when they first ran in my regular hiking column will enjoy them even more the second time around.

As for the rest of the book, it features previously unpublished pieces that have been in the making for years but are just now seeing the light of day. Among these pieces is the compendium of trail guides and trail-builders that serves as the final chapter in this book. While I'd like to think that this compendium is pretty complete, I am sure I've overlooked a few deserving individuals, so if there are any omissions, I take full responsibility for what doesn't appear in these pages.

Just to set the record straight, the period of time covered in the book basically runs for one full century, beginning with the construction of the historic

Preface

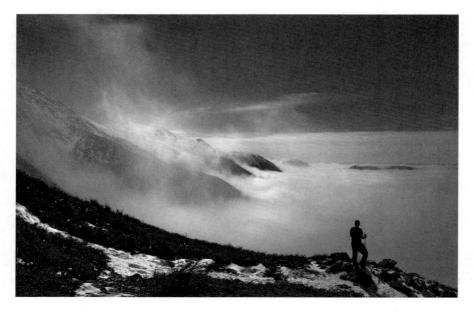

A winter undercast provides the dramatic backdrop for this descending hiker on Mount Washington's Jewell Trail. *Photo by Chris Whiton.*

Crawford Path in 1819 and running to about 1920, when the White Mountain trail system was more or less unified, with paths by then connecting one region of the Whites to another. In covering a century's worth of trailblazing, I've tried to hit on multiple topics and individuals, from the earliest builders of these enduring footpaths to folks like Bethlehem's Allen "Old Man" Thompson, who was not a trail-builder, per se, but was someone who probably knew the many nooks and crannies of the western White Mountains better than anyone in the latter half of the nineteenth century.

I've also chronicled a select number of history-making adventures that have either received just passing notice in previously published books or no mention at all. A prime example of the latter is the forgotten last horseback ascent of the Crawford Path back in the summer of 1932. This unusual ascent of Mount Washington probably took place a full half century after the last such occurrence. If not for a one- or two-line mention of this event in F. Allen Burt's *The Story of Mount Washington*, published in 1960, I doubt I'd ever have learned of its taking place.

As with the omissions noted earlier, I willingly take full responsibility for any factual errors that have made their way into the text. If readers do find mistakes, by all means let me know so that in future editions of this work, or any other I might produce, I get all the facts right.

Acknowledgements

When it comes to acknowledging all those who played a role in making this book project come to fruition, I can say for certain that there is no shortage of individuals and organizations deserving of recognition. Everyone, and I do mean every person or group I approached for advice, help or historical background, assisted in some way, shape or form. There were no exceptions. But that was not surprising at all, given the intense interest in these parts for anything related to White Mountain history.

One resource I tapped early and often were area historical societies, and I cannot stress enough how appreciative I am for the assistance given to me by Randy Bennett of the Bethel (Maine) Historical Society, Reuben Rajala of the Gorham Historical Society and Carol Riley of the Upper Pemigewasset Historical Society based in Lincoln, New Hampshire. Likewise, area libraries and their incredible staffers went out of their way to secure for me books, newspaper articles and old photographs. Especially helpful was the staff at my hometown library in Littleton; Peter Crane, keeper of books, pictures, postcards and just about everything else at the Gladys Brooks Memorial Library at the Mount Washington Observatory's headquarters in North Conway; and Becky Fullerton of the Appalachian Mountain Club's wonderful library on Joy Street in downtown Boston.

The many photographs—old and new—that grace the following pages were supplied by both organizations and individuals who I called on in a near panic when I realized I had but a month or so to assemble a representative collection of images. Judy Hudson of the Randolph Mountain Club was

Acknowledgements

most helpful in offering me multiple images from that club's vast digital archives. The same goes for fellow White Mountain history buff David Govatski, whose enormous postcard collection is probably unrivaled when it comes to images of mountain hikers. I also tapped into the photo archives of the aforementioned Mount Washington Observatory, the Appalachian Mountain Club (AMC), Lost River Reservation in North Woodstock and the Mount Washington Auto Road.

I was also fortunate to have at my immediate disposal the fine work of contemporary hiking photographers Chris Whiton and John Compton. My longtime hiking buddy and frequent writing partner Steven D. Smith also loaned me use of several images from his varied journeys throughout the Whites.

Others who shared their historical knowledge of the region or who provided invaluable background material for some of the individuals and/or topics covered in this book included Jack and Jere Eames of Littleton, Steve Sabre and Kris Pastoriza of Easton and logging railroad historian Bill Gove. I am certain that there are others as well, but for the moment their names escape me. Please forgive me if you've been overlooked.

Working with the good folks at The History Press has also been a very positive experience. I am convinced that Dani McGrath's early enthusiasm for this project is what got it truly off the ground just a few short months ago. In the preproduction phase, it has been my pleasure to work closely with Jeff Saraceno, who has shepherded this book through the process with grace, humor and the patience of Job. I'll do better next time around, Jeff, I promise.

Finally, no one has put up with more disruptions of everyday life, nor provided more moral support and unwavering enthusiasm, than my wife, Jeanne. She was the one, some twenty years ago now, who convinced me to write my first hiking book, and she was the one who this time around again urged me to forge ahead with yet another crazy book idea, conjured up during the dark, cold nights of early winter. As always, thanks for being there.

The Crawfords and Mount Washington

In the month of May [1819] four gentlemen came on horseback to visit the mountains. I gave them the best information I could. They set off together and made the best they could of their excursion through the forests, but suffered considerable inconvenience by the thickness of the trees and brush, which would every now and then take hold of their clothes and stop them; but they succeeded in reaching the top...
As this was the third party which had visited the mountains since I came here to live, we thought it best to cut a path through the woods from the Notch out through the woods, and it was advertised in the newspapers, and we soon began to have a few visitors.
 —Ethan Allen Crawford, as told to his wife, Lucy Howe Crawford, 1845

Even though sporadic explorations of New Hampshire's tallest mountains had been ongoing for a century and half, if there's a time and place to be considered the birth of recreational hiking in the White Mountains, the late spring and early summer of 1819 in Crawford Notch are it. For this is when and where pioneer settlers Abel and Ethan Allen Crawford constructed what is generally considered to be the oldest continuously used hiking path in America.

This crude footpath, which stretched more than eight miles from the height of land at the top of Crawford Notch (then known simply as the White Mountain Notch) to the summit of Mount Washington, advanced at first through three miles of trackless forest before breaking out above the tree line near the peak Abel Crawford usually called Bald Mountain (today's Mount Pierce or Clinton). From there, the sparsely marked trail followed the

wide boulder- and scrub-filled ridge between Bald Mountain and the next major summit to the north, Mount Pleasant. The rest of the way, all well above the point where trees are able to grow, the path wound its way over and around several intermediate peaks before finally ascending the rocky, barren cone of Mount Washington itself.

If you are at all familiar with the White Mountains' history, then you are also probably familiar with the Crawford name, for no other family is more linked to the early days of the region than them. Besides being among the first settlers in a region that was practically devoid of any human activity in the latter stages of the eighteenth century, the Crawfords can also lay claim to being the first generation of path-builders on New England's greatest mountain range, with the tallest peak in New Hampshire being the ultimate end goal of their early trail work.

Given that the 6,288-foot peak is the highest in the Northeast and for a century and a half prior to 1819 had been the object of several well-chronicled exploratory visits, it's no surprise that this bold, dominant landmark would come to host the first permanent recreational footpath in the country. Ever since Englishman Darby Field led the first known expedition up the mountain in the late spring of 1642, Mount Washington had been the object of fascination. This is true even though mountains in general were then considered inhospitable places, and the White Mountains (and Mount Washington, in particular) were especially feared by the Native Americans inhabiting the region.

Darby Field's first ascent of the mountain in the late spring (probably June) of 1642 was the highlight of his nearly three-week journey from New Hampshire's seacoast region to the interior mountains well to the north and west. Accompanied by two American Indians, Field climbed the mountain from the Saco River Valley to the south, and although historians are unsure of his exact route, it is near certain that he and his native companions passed near the two Lakes of the Clouds just southwest of the summit. Field followed his landmark trek with a second trip up the mountain just a few weeks later.

That same year, in late October, Thomas Gorges and Richard Vines, deputy governor and councilor, respectively, of the Province of Maine, also journeyed to the summit hoping to find "shining stones" said by Field to be lying atop the mountain. For all their effort, though, Gorges and Vines came up empty-handed, and it may be because of this that no further confirmed ascents were made of the mountain until well into the next century. Even then, visitors to Mount Washington were few and far between, and that would not change until the arrival of the Crawford clan about 150 years later.

The first of the Crawfords to take root in the secluded pocket of the White Mountains known then as Nash and Sawyers Location was Abel Crawford, the legendary patriarch of the family who, along with his wife, Hannah, raised eight boys and one girl. Born in 1866 the son of John and Mary (Rosebrook) Crawford and the grandson of Scotch-Irish native James Crawford, Abel Crawford spent his childhood years in Union, Connecticut, before his family migrated north, eventually settling in the upper Connecticut River Valley town of Guildhall, Vermont.

It's anyone's guess as to why Abel chose to uproot himself (and eventually his young family) and leave the fertile growing fields along the Connecticut River for the unknown wilderness country at the western base of Mount Washington, but that's exactly what happened in early 1791. The newly married Crawford, already with one infant son (Erastus) and another (Ethan Allen) on the way, trekked twenty-five miles from his Vermont home to the valley of the winding Ammonoosuc River. There he came upon a few squatters who had constructed several cramped, crude log huts and who were trying to scratch out a living in the unforgiving land barely six miles from the Presidential Range peaks.

For Crawford, it must have been a "love at first sight" moment, for in short order he bought out the squatters and promptly settled in for nearly a year of solitary living and toil. It wasn't until after his second son, Ethan, was born in January 1792 that Abel chose to bring his wife and two young sons to live with him at his rustic retreat.

If it was Abel Crawford's intent to transform his Nash and Sawyers Location land into a livable, workable tract, then he must have

Pioneer settler Abel Crawford, with the help of his son Ethan, constructed the historic Crawford Path, the longest continuously maintained hiking trail in America. *Author's collection.*

been at least a bit disconcerted just a few months later when his father-in-law, Eleazar Rosebrook, paid a visit to the Crawford family and almost immediately decided that this, too, was where he wanted to live. "Rather than to be crowded by neighbors," recalled Ethan Allen Crawford years later, his father opted to move "twelve miles down the Saco river, where he would have elbow room enough; and then he began in the woods, in what is called Hart's Location."

Abel Crawford did his best to tame the wild country surrounding him, clearing the crowded forest to make way for planting and growing food. Then, later in life, after the state legislature authorized the building of a turnpike that ran past his home and up through rugged Crawford Notch, he starting catering to the growing number of travelers making their way back and forth between the seacoast, the mountains and the same productive farmlands of the Connecticut River that he once knew so well.

If Abel is considered the patriarch of the famous Crawford clan, then his second son, Ethan Allen Crawford, has to be considered the "rock star" of the pioneering family. Perhaps the best-known figure in White Mountains annals, tall, gangly Ethan stood well over six feet, reputedly had the strength of several men and made his mark on the region as an innkeeper, guide, path-builder, hunter, trapper and fisherman. The fact that he endured one financial hardship after another during his relatively brief life has only added to his stature as a White Mountains legend.

Born in Guildhall, Vermont, and raised at his father's home in Hart's Location, Ethan Crawford left his mountain home at the age of twenty after enlisting as a soldier. Following a bout with spotted fever that forced him to return to his New Hampshire home for a time, he returned to upstate New York to fulfill his military obligations and, for several years afterward, took on a number of different jobs, including road-building, farming and transporting five-hundred-pound barrels of potash downriver on boats. Ethan fully intended to remain in New York, where a brother of his also lived, and went so far as to acquire some land in Louisville, New York. But in 1816, he decided to return once again to the White Mountains after learning by letter that his grandfather, Eleazar Rosebrook, was in ill health, suffering from cancer of the lip.

At the time, Ethan had no ambition to stay on permanently at his grandfather's home at what is now known as the Bretton Woods region. But at the urging of the sickly Rosebrook, who also ran an inn for travelers, he decided to stay. Ethan returned to New York briefly, sold off his property there and was back in the White Mountains by March 1817.

It must have been a hectic first year back for the young Crawford, as first he witnessed his grandfather's slow, painful death in September. Then, two months later, he wed Lucy Howe, a first cousin of his who'd been enlisted earlier in the year to take care of Rosebrook during his lengthy convalescence. It was Rosebrook, in fact, who had pushed for Ethan to marry his cousin. Unfortunately, the elder Rosebrook had already passed on when the couple wed on November 1, 1817.

During their nearly thirty years of marriage, Ethan and Lucy faced one personal crisis after another, including devastating fires and ongoing financial woes, most of which are chronicled in Lucy's classic book, *History of the White Mountains*, published in 1845. Of these, perhaps none is more poignant than the one that took place in July 1818, when their home was destroyed by an accidental fire just hours after Lucy had given birth to the couple's first child, a five-pound boy. Ethan and his wife must have been both ecstatic and crushed by the sudden turn of events.

Fortunately for the Crawfords, they were not without a home for long, as a vacant, smaller structure (just twenty-four feet square) a mile and a half down the road was at their disposal. Within a few days, neighbors and family members teamed up to move the building to a spot close by the charred ruins of the old Rosebrook place. And in these cramped quarters, Ethan and Lucy Crawford would endure, accommodating travelers as best they could given the lack of available room. For parties of any considerable size, however, Ethan had no choice but to send them to his father's larger inn, some twelve miles away in Hart's Location.

Operating inns at each end of the notch, Abel and Ethan were perfectly positioned to witness the increasing interest in nearby Mount Washington, even though no paths up the mountain existed at that time from either the Saco or Ammonoosuc River Valleys. As noted by Frederick Tuckerman in the June 1919 issue of *Appalachia*, the journal of the Appalachian Mountain Club, attempts to reach the top of the mountain from the west were becoming more frequent as the years advanced. In the summer of 1807, for instance, Dr. George Shattuck of Boston, a recent Dartmouth College graduate, visited the White Mountains in July and with a party of five others ascended Mount Washington from Rosebrook's inn with the purpose of gathering scientific information. It took the men two days to reach the summit, where it was a balmy sixty-six degrees at the top.

Colonel George Gibbs, a mineralogist, also ascended the mountain twice during the summer of 1809—once from the eastern side and once from the west (Rosebrook's). Though he's never been given much credit for it,

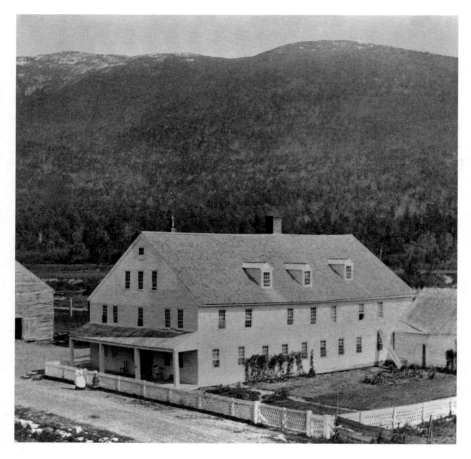

The Mount Crawford House, longtime home of Abel Crawford, stood at the south end of Crawford Notch near today's Notchland Inn. The Davis Path, built in 1844–45, began a short distance from the inn. *Appalachian Mountain Club Collection.*

Gibbs, probably in 1809, actually commissioned the first blazed path up the mountain. It's thought that this crude path hacked out through the scrub growth just below timberline passed through Tuckerman Ravine on the mountain's eastern slopes. Just how long this path was in existence is unknown, and modern-day historians have long wondered if the so-called Gibbs Path is the same one referenced by late nineteenth-century guidebook editor Moses F. Sweetser, who wrote of an ancient path up Mount Washington used by explorers coming from the vicinity of Jackson.

 Between the time of the devastating fire that destroyed the old Rosebrook inn in July 1818 and May of the following year, Ethan Crawford notes that three additional parties visited the mountain, two of which hired

his father, Abel, to guide them along the way. The first of these parties included Colonel Binney of Boston and two young men, who struggled mightily just to get above the tree line and onto the open expanses of the southern peaks. "They had much difficulty in managing to get through; they, however, proceeded slowly; sometimes crawling under a thicket of trees, sometimes over logs and windfalls, until they arrived where they could walk on top of the trees," wrote Ethan. "This may seem to some strange, but it is nevertheless true. They never reached the summit but managed to get along on some of the hills."

After a second group of travelers hired Abel Crawford to guide them up the mountain in September 1818, and then a group of four men on horseback sought guidance from the Crawfords the following May, Abel and Ethan made the decision to construct a footpath from the top of Crawford Notch to the summit of Mount Washington.

In reading Lucy Crawford's *History of the White Mountain*, it's all but impossible to envision just what this historic path must have looked like back in 1819, when it was probably a path in name only, with no real semblance of a modern, well-trodden track through the woods. Fortunately, there does exist at least one written account of an ascent of the Crawford Path during its first year of existence. It comes courtesy of well-known nineteenth-century abolitionist Reverend Samuel Joseph May (1797–1871) of Boston, who in 1873 had his memoirs posthumously published.

May was an 1817 graduate of Harvard University and later in life would be known as a "fearless and uncompromising abolitionist" and "antislavery lecturer." In the chapter from his memoirs titled "Horseback Journey to White Mountains," May recalled the September trip up the mountain in which he was joined by several others from his touring party. This group included close friend George B. Emerson, classmates Samuel E. Sewall, Caleb Cushing and Joseph Coolidge, school friend William Ware and Joseph Moody, a cousin of Emerson.

May wrote that the party, being guided by Abel Crawford, struck off up the newly built trail in midafternoon and "toiled up about half way to a spot where we were told it would be best for us to spend the night, and where there was a rough bark shed about twelve feet long and eight feet deep, open in front" that had been constructed by the Crawfords. The shelter was probably one mile or so below the summit of Mount Clinton (Pierce) or about two-thirds of the way up to the tree line.

After a night of sound sleep on soft hemlock boughs gathered in the nearby woods, the adventurers awoke the following morning "just as the

One of the earliest accounts of a hike along the Crawford Path is that of well-known nineteenth-century abolitionist Samuel Joseph May. *From* Life of Samuel Joseph *(May 1873).*

sunlight was gilding the tops of the trees" and enjoyed an excellent breakfast prepared in part by "Old Crawford" himself. By seven o'clock, the party was on its way, following a path that May wrote "was narrow, so that much of the way we were obliged to follow our leader in single file. It was obscure, often determined only by marked trees, some of which 'Old Crawford' alone could discover. But he confidently assured us he knew the way."

At about nine o'clock in the morning, May wrote that a fog settled in over the mountain, creating some confusion for Crawford. "Our guide was perplexed, and, bidding us stay where we were, went off to explore," recalled May. "He got back in less than an hour. He had found what he was sure he had not lost—his way."

As the fog burned off, May and his party continued on their way toward Washington, apparently reaching Mount Monroe at midmorning, where "we could see what remained to be accomplished—a descent of several hundred feet into the valley between, and then the ascent to the summit of Mount Washington, three or four hundred feet higher than we had yet climbed."

The group reached the Lakes of the Clouds (or "Washington's punch-bowl," as he called them) around noon, and after a short break for lunch and drink, they started up the summit cone. "It was much steeper and more difficult than any we had yet attempted; but we accomplished it in less than an hour, for at one o'clock we stood upon the summit of Mount Washington."

At the summit, May said, "We found it quite cold, and a good deal of ice there, but we were loath to quit the height we had reached with so much toil." By the writer's description, it appears that there was at least a partial undercast at the time, which must have further convinced May and his party to linger as long as possible atop the exposed, shelterless peak. "We had risen to a region above all mists and clouds. There they lay far below us; and as the

rays of the sun struck upon their upper surfaces, they looked just like banks of the whitest snow."

At about two o'clock in the afternoon, the group left the summit and began to retrace its steps along the southern peaks of the Presidential Range. While some of the explorers, including May, opted to spend a second night at Crawford's bark shed on Mount Clinton, Cushing, Coolidge and Emerson continued on down the mountain and into Crawford Notch, where they spent the night at the inn that would in a few years be known as the Willey House.

With the construction of this new cleared path up Mount Washington, the western approach became the favored one among people wishing to climb the mountain, all but ending ascents from the east side and Pinkham Notch. And as word got out about the new Crawford Path, the number of people seeking the Crawford's guidance up the mountain increased—so much so that by the spring of 1821, just two years after the Crawford Path was built, Ethan Allen Crawford decided that it was time to construct a second path up the mountain, this one on a more direct line from his dwelling at Bretton Woods.

The second Crawford Path followed the Ammonoosuc River all the way to the base of the mountain, much as the Cog Railway Base Road does today. From there, the path followed "a ridge or spur of the hill," more or less climbing the same route that would later be used by the Cog Railway. "We could now ascend without much difficulty," wrote Crawford.

Before too long, use of the new path up the mountain superseded use of the original route along the Southern Peaks. Among the early users of the new path were Norwich University founder Captain Alden Partridge and a contingent of teenage cadets from the school; the three Misses Austin (Eliza, Harriet and Abigail) of Jefferson (and formerly of Portsmouth), who became the first women to successfully reach the summit; and well-regarded botanist William Oakes, who came to know Ethan Crawford quite well during his many visits to the White Mountains between 1825 and 1846, the year of Crawford's death.

For Crawford, the next logical step was to erect some sort of shelter on the upper slopes of the mountain. "The experiences of parties cloud-bound on the summit showed the need for such a refuge," wrote F. Allen Burt in his insightful book, *The Story of Mount Washington*, published in 1960. So, in July 1823, "Another man and myself took blankets, provisions, and other necessary things for a small party who were going to stay the second night on Mount Washington, as they were desirous of being there and seeing the

appearance of the sun when it should set in the evening and rise in the morning," recounted Crawford years later. "After staying at the foot of the hill over night, we ascended, and being there in season, went to work and built three stone cabins. We then collected a quantity of dry moss, laid it in them for beds, spread our blankets, and at an early hour, on this elevated spot, retired to rest...This was the first night I ever slept on Mount Washington."

By his own admission, Crawford said that his stone cabins were a miserable failure, owing to the damp nature of the mountain. "They were not considered healthy to remain over night," he noted. Bound and determined to build some sort of permanent shelter near the summit, however, Crawford next erected a large tent, sufficient to accommodate as many as eighteen people, near a mountaintop spring. Predictably, given that the mountain is frequently battered by hurricane-force winds, the so-called Tip-Top House tent did not hold up to the elements and quickly wore out. Having failed twice at establishing a permanent shelter on the mountain, Ethan opted not to make a third attempt.

The Crawford family's presence in the area just west of Mount Washington continued for several more decades, although neither Ethan Allen Crawford nor his aging father would bother to construct any other paths up the mountain. In the fall of 1827, Abel and Ethan did build a new inn at the top of Crawford Notch to accommodate the increased number of visitors passing through the area in the aftermath of the disastrous Willey Slide avalanche of August 1826 that claimed nine lives. This 120- by 36-foot building, known as the Notch House, was run by one of Ethan's younger brothers, Tom Crawford, and over the years would see a host of notable guests, including New Hampshire native and statesman Daniel Webster, Ralph Waldo Emerson, Washington Irving and Nathaniel Hawthorne.

Young Tom Crawford, who operated the Notch House for nearly a quarter of a century, is credited with later converting the Crawford's original path up Mount Washington into a bridle path in the fall of 1839 and the spring and summer of 1840. According to historian Burt, Tom Crawford's hired hand, Joseph S. Hall, was the driving force behind the bridle path project. Hall had been guiding Notch House guests up the mountain for several summers but had become increasingly concerned with the difficulty of the journey. He convinced Tom of the need for a bridle path and wound up supervising its construction, completing the work as far as Mount Clinton in 1839 and extending it all the way to Mount Washington the following year.

When the new bridle path was finally ready for use late in the summer of 1840, it seemed only appropriate that Tom Crawford's father, seventy-

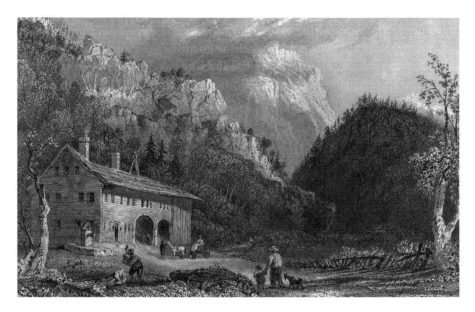

An early engraving of Thomas Crawford's Notch House, situated not far from the foot of the Crawford Path. *Mount Washington Observatory Collection.*

five-year-old Abel Crawford, would be the first to ride a horse all the way to the summit. This he accomplished in the company of state geologist Dr. Charles T. Jackson, for whom nearby Mount Jackson would later be named, and the geologist's two assistants. (See the chapter "Horseback Ascent of the Crawford Path" for a more detailed account of this ascent.)

The opening of the bridle path resulted in almost daily horseback ascents of the mountain by guests staying at the Notch House. It also spawned a similar conversion of the Crawfords' other path up Mount Washington. This project was undertaken by Portland, Maine businessman Horace Fabyan, who several years earlier had purchased Ellen Allen Crawford's Bretton Woods property after foreclosure proceedings had wrested the property away from the financially beleaguered pioneer. The Fabyan Bridle Path, as it was known, "became one of the principal routes to the top of the mountain," wrote Burt. "In its busiest days as many as a hundred visitors made the ascent."

In the 1840s, Crawford family members built two additional bridle paths in the vicinity of Crawford Notch, one up Mount Washington and the other up 2,800-foot Mount Willard at the head of the notch. Nathaniel T.P. Davis, the husband of Abel Crawford's lone daughter, Hannah, built a

fourteen-mile-long path from Abel's old hotel in Hart's Location to Mount Washington by way of Mount Crawford and the long Montalban Ridge extending south from the mountain. Built in 1844–45, the Davis Path was never a popular route, probably because of its length, and within a decade, it had pretty much been abandoned. Proving much more popular was Tom Crawford's bridle path up Mount Willard, built in 1846. This path served as a forerunner for the much-loved hiking trail that exists on the mountain to this day.

After a presence of more than five decades in the immediate area of the notch, the Crawford family had all but disappeared from the scene by the mid-1850s. Ellen Allen Crawford, whose colorful life is so well told in his wife's book, died on June 22, 1846, at the age of fifty-four, while his father, Abel, outlived his son by more than five years, finally passing away at his longtime home in Hart's Location on July 15, 1851, in his eighty-fifth year.

As for Tom Crawford, he managed the Crawford family's Notch House and, for a brief period, the original Crawford House hotel until forced to sell out in 1852. Nathaniel Davis, Abel's son-in-law who ran Abel's Mount Crawford House, lost his property to foreclosure at about the same time.

From a mountain traveler's perspective, there's little doubt that the Crawfords played as significant a role as anyone in making the highest

The Crawford Path traverses the southern peaks of the Presidential Range, including Mount Monroe, seen here towering above and behind the Appalachian Mountain Club's Lakes of the Cloud hut. *Photo by John Compton.*

peaks of the White Mountains accessible to the growing number of tourists coming to the region. Their early paths, though crude by modern-day standards, opened up the mountains to a new breed of explorers, especially those seeking out a different kind of adventure.

These early footpaths, in truth, led far beyond Mount Washington, for they opened up possibilities no one could have foreseen at the time Abel Crawford first laid eyes on the two squatters' cabins he would soon purchase. These first mountain paths were merely the start of something much bigger down the road.

Path-Making in Franconia Notch and the White Mountains

While it seems that most of the path-building taking place in the White Mountains during the first half of the nineteenth century centered on Mount Washington and the Presidential Range, by 1850 other areas of the Whites had also gained interest with the public.

The mountain pass best known as the home of New Hampshire's most familiar face, the iconic Old Man of the Mountain, was certainly the scene of some of this early trail activity. From the height-of-land in Franconia Notch, where today's Franconia Notch Parkway passes through, the first path to the top of 5,260-foot Mount Lafayette was established in 1826 by two Littleton men who would later become associated with several well-known mountain hotels. Stephen C. Gibb and his son, Joseph Lane Gibb, supervised construction of the path, which is believed to have followed closely the route of the present-day Greenleaf Trail. The building of this trail coincided with the two earliest published accounts of Mount Lafayette ascents, the first of which appeared in print in September 1826 and the second in June 1827.

This first path up Mount Lafayette, high point of the chain peaks running along the east side of Franconia Notch, more than likely departed from the floor of the notch somewhere close to the site of the present-day Aerial Tramway on neighboring Cannon Mountain. The footpath climbed steeply to the wild, narrow cleft in the ridge known as Eagle Pass and then ascended the mountain in a southeasterly direction, reaching timberline not far from where the Appalachian Mountain Club's Greenleaf Hut now stands.

White Mountains Hiking History

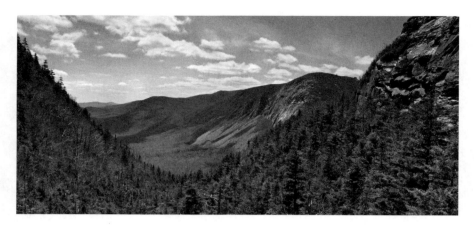

The first trail up Mount Lafayette, constructed in 1827, passed through wild Eagle Pass. *Photo by Chris Whiton.*

An anonymous account of an ascent of Lafayette in 1827, printed in the December 1954 issue of *Appalachia*, reveals the character of this path, which was but a year old at the time. "Turning to the left, we immediately began to ascend the mountain in a rough path, which bore the foot steps of some former pilgrims, who had conquered the rugged ascent to gratify curiosity, that insatiable curiosity which induced us to undergo the toil which we now began to experience," wrote the unknown climber. "The ascent was very steep and the path rough. We were under the necessity in many places of laying hold of bushes, or whatever came within our reach and we derived nearly as much aid from our hands as we did from our feet…The whole mountain appeared to be an immense pile of rocks…overspread with a thick carpet of moss. Spruce trees of a small dimentions [*sic*] formed a principle part of the wood, and then diminished in their size, in proportion as we advanced to the summit."

About two-thirds of the way up the mountain, the climbers "came to a place of a few rods square, partially cleared, which we were informed, was the encampment of the pioneers who first opened a path of the mt. A few rods farther we came to a small pond whose waters appeared to be replenished principally by the rains as we discovered no stream that entered it and its situation precluded the possibility of its being supplied by springs." [The pond the writer refers to here no doubt was the Eagle Lakes near present-day Greenleaf Hut.]

From the pond, the climbers "began to tread the bald pate of Mt. La Fayette," which was enveloped in fast-moving clouds, and in due time made it to the summit, where a small cabin "8 by 16 feet enclosed with a stone wall,

with fireplace and chimney at on end" had been erected, presumably during the previous year. Here, the party of climbers spent a chilly, uncomfortable night, but all were delighted at the splendid prospects brought on by the dawn of a new morning.

Like Crawford Notch to the east, Franconia Notch became a fairly well-traveled route through the mountains once a suitable wagon road was put through with the state's blessing and funding. By virtue of this new road, settlers from the north seeking passage to points in the southern part of the state could now avoid the long and circuitous route that usually took them along the Connecticut and Baker River Valleys well to the west. Thus, it is probably no accident that the first path up Mount Lafayette was built the same year that the former cart path through Franconia Notch was upgraded.

As previously noted, the builders of this first path up Mount Lafayette went on to become well-known hoteliers in the Whites. In 1835, nine years after constructing the route up the mountain, the Gibbs family opened the first hotel in Franconia Notch right at the base of Mount Lafayette. The Lafayette House (or Gibbs' Hotel, as it was sometimes known) "stands completely wedged in between the heights," wrote New Hampshire historian George Barstow in 1842. It was situated about five hundred feet southeast of the site of the later Profile House and was owned and operated by the Gibbses until 1852, when they sold it to entrepreneur Richard Taft and several associates. Joseph Gibbs would later go on to manage the famous Crawford House at Crawford Notch, a structure originally built by Thomas Crawford of the pioneering family of such White Mountain fame.

Another major path developed in the first half of the nineteenth century was a trail up Mount Moosilauke in the southwestern corner of the region. This massive mountain, lying not far from the upper Connecticut River Valley, had been visited on several occasions between 1770 and 1820, with moose hunter Chase Whitcher of Warren most likely the first settler of the region to reach its top back in the early 1770s. A scientific expedition up the mountain by Dr. Ezra Bartlett and Samuel Knight, sometime around 1800, has also been noted, as well as an 1817 visit by Captain Alden Partridge, the indefatigable walker from Norwich, Vermont, who ascended Moosilauke's South Peak. (Another story that has long made local rounds is that two soldiers belonging to the famed Rogers' Rangers made it to the summit of Moosilauke back in 1859 while retreating from their raid on the St. Francis Indian settlement in Quebec. One of the rangers, Robert Pomeroy of the Manchester area, is said to have perished atop the mountain, while his companion barely made it down alive.)

White Mountains Hiking History

Moosilauke's first trail was cut in 1840 by a group of local settlers supervised by William Little of Warren, a local innkeeper who'd promised anyone who would lend a hand that they'd receive "all the grog they could drink" for their efforts. As the workers gathered at the summit after completing the path, Little, recalling the event in his 1870 *History of Warren*, wrote glowingly of the panorama spread out before him and his friends. "The blue sky is above them; no smoke, no clouds are there. Silver lakes and flashing rivers lay beneath them. A thousand mountain peaks bathing their heads in the bright sunshine are around them. There are peaks sharp and angular, wavy wooded mountain crests, great cones standing alone, dome shaped mountains dark and sombre." In other words, it was a glorious day to be atop the mountain. Little's path generally followed the route of today's Glencliff Trail, and like so many of the early paths in these mountains, it was eventually converted to a bridle path.

The 1840s, however, saw little other new path-building activity in the Whites, save for the conversion of the two Crawford-built paths into bridle trails, construction of the Davis Path near Abel Crawford's place and Tom Crawford's addition of a bridle path up Mount Willard. According to Moses Sweester in his 1876 edition of *Osgood's White Mountains*, in about 1840, a footpath leading "through the woods and dwarf shrubbery" to the top of Mount Washington was built from the Elkins farm in Pinkham Notch. By the mid-1870s, however, this route had "long been forgotten," wrote Sweetser.

Also in the early 1840s, Horace Fabyan, the Portland, Maine businessman who'd taken over Ethan Allen Crawford's property at Bretton Woods in 1837, built a new bridle path from his hotel up to the top of Mount Pleasant (today's Mount Eisenhower). The so-called Mount Pleasant Path apparently intersected the original Crawford Path just to the south of the mountain's domed 4,760-foot summit, and although its use waned as the years went on, its upper section was still "well preserved," reported Sweetser in his 1876 guide.

Guy Waterman, in his invaluable book, *An Outline of Trail Development in the White Mountains: 1840–1980*, mentioned one other path developed right around 1850. The trail led to little-known Thompson Falls behind dramatic Whitehorse Ledge near North Conway. Built by artist Benjamin Champney, who summered in the Conway area, the path led to a pretty series of cascades along a brook that feeds into nearby Echo Lake. Sweetser's first guidebook includes a brief mention of the falls, noting that they are about four and a half miles from North Conway, "graceful, rather than otherwise notable" and seldom visited.

Trailblazers of the Granite State

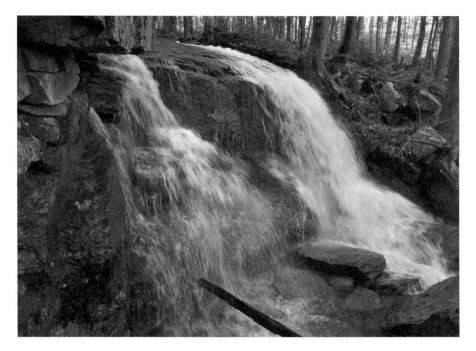

Thompson Falls near North Conway were first accessible by a trail cut by nineteenth-century artist Benjamin Champney. *Photo by John Compton.*

If the Crawfords (and, to some extent, the Gibbses, William Little and Horace Fabyan) represented the first generation of path-builders in the Whites, then the second generation consisted of the new breed of innkeepers and hoteliers who were steadily growing in number as more and more summer visitors began to make the mountains their vacation destination in the 1850s. In fact, just about every new path constructed in the region during this period owed its existence to businesses catering to tourists.

The numerous hotels that began popping up here and there in mountain country were a byproduct of the emergence of the rail industry as a major player in the development of a region that had previously been difficult, at best, to access. As author Frederick W. Kilbourne stated in his definitive early history of the Whites, *Chronicles of the White Mountains*, the railroads were "an essential and very great element in the growth, and indeed, in the very existence, of the region as a summer resort."

Up until the first trains began rolling into the White Mountains in the summer of 1851, the rigorous ordeal of traveling great distances by horse and wagon over poorly built roads tried the souls of even the hardiest

White Mountains Hiking History

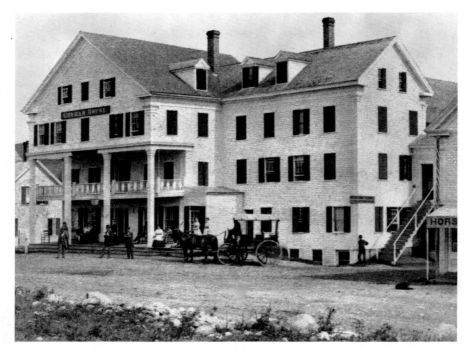

With the coming of the railroad to Gorham in 1851, construction of hotels such as the Gorham House followed quickly as visitors enjoyed the ease of riding the rails to the White Mountains. *Bethel (Maine) Historical Society.*

travelers. For the folks living in the large, populous cities of the Northeast, this deterred many potential visitors from making their way into the White Mountains.

It wasn't long after the first train pulled into Gorham, New Hampshire, from Portland, Maine, on July 23, 1851, that new hotels and inns were established both along the rail lines and at outposts closer to the actual mountains themselves. In Gorham, for instance, officials with the Atlantic & St. Lawrence Railroad built a new hotel called the White Mountain Station House to accommodate the many riders they expected would use their new rail line. The hotel was leased two years later to John Hitchcock, who had previously managed hotels in Boston and Fall River, Massachusetts. Hitchcock later played a huge role in the development of several mountain paths in and around the Gorham area. Downtown Gorham also saw the erection of the Gorham House in 1853 by local merchant Hazen Evans.

Meanwhile, eight miles or so from the railroad depot in Gorham, developments were also taking place at the eastern base of Mount

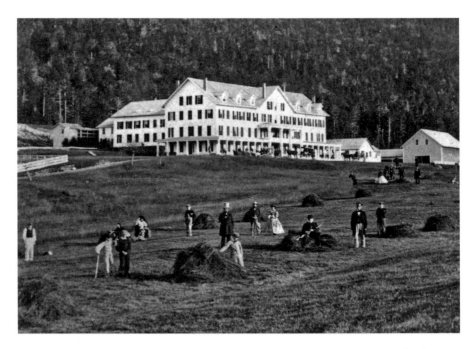

Grand hotels like the original Glen House in Pinkham Notch served as catalysts for the construction of new footpaths in the White Mountain, as guests were always looking for places to explore on foot. *Bethel (Maine) Historical Society.*

Washington in a large clearing along the Peabody River commonly known as "the Glen." In 1850, land speculator John Bellows of Exeter "conceived of erecting a public house" in this vicinity and promptly rehabilitated an old dwelling on land he'd previously purchased. The Bellows' Farm House, though short-lived, would soon become one of the region's first major grand hotels following its purchase by Colonel Joseph Mariner Thompson in the spring of 1852. He immediately added on to the house, increasing the number of guests rooms to somewhere between twenty and thirty, and changed its name to the Glen House. By 1853, he had enlarged his house yet again, making it one of the biggest hotels anywhere in the region.

Rail development wasn't just confined to the eastern Whites, of course. The extension of the Boston, Concord & Montreal Railroad into the southern and western parts of the Whites was probably just as important as the direct line from Portland to Gorham, as the BC&M would be the railroad of choice for visitors looking to reach the mountains from Boston and points south. The BC&M was chartered in 1844, had reached New

Hampshire's Lakes Region by 1848 and was running trains to Plymouth by January 1850 and to Littleton by December 1853. These developments, in turn, led to a similar boom in local hotel construction, and with these new lodging establishments, especially those closest to the mountains, came the need for new recreation trails to be used by the summertime guests.

In the Pinkham Notch area, where Colonel Thompson was gradually turning the wood-framed Glen House into the finest resort complex in the eastern White Mountains, the landlord was also busy developing paths to some of the finer points of interest in the immediate area. These included a footpath to another "Thompson Falls" on nearby Nineteen-Mile Brook and a new bridle path up Mount Washington, this one scaling the mountain from the northeast. The Glen Bridle Path zigzagged up the mountain on a course approximately seven miles long, following the same ridge that within a decade would be used in laying out the Mount Washington Carriage Road. In 1858, Thompson also arranged for construction of the first path linking the Glen House site with Tuckerman Ravine, the great glacial ravine on the mountain's southeastern slopes. Thompson's Path, as it was then known, would later be improved by another trail enthusiast, Major Curtis B. Raymond, and has since been renamed the Raymond Path.

On the heels of Thompson's growing success at the Glen House, it did not take long before more major developments began taking place at the summit of Mount Washington. The biggest of these was the building of the first hotel at the top of the mountain in 1852 by local businessmen Nathan Perkins of Jefferson, Lucius Rosebrook of Lancaster and Joseph Hall. This was the same Joseph Hall who thirteen years earlier had aided Tom Crawford in converting the first Crawford Path into a bridle route.

Construction of the summit structure led to yet another bridle path being built up the mountain as sheathing and roofing materials were to be transported to the summit by horse from a sawmill in Jefferson Highlands. The resulting Stillings Path (named for its builder, John Stillings of Jefferson) was about nine miles in length, and in its initial course, it followed pretty much the route of today's Jefferson Notch Road. After emerging from the heavily forested lower slopes, the path eventually crossed over the upper slopes of Mounts Jefferson and Clay, coming within one mile of Jefferson's rock-crowned Castellated Ridge, and it eventually joined the Fabyan Bridle Path less than one mile from the summit. As noted by Waterman, completion of the Stillings Path meant that Mount Washington was now served by five different bridle paths but not a single pure walking path.

Elsewhere in the Whites, similar trail activity was taking place in areas where other new hotels were going up. At the height-of-land in Franconia Notch, where the Lafayette House had been a going concern for more than fifteen years, the Flume and Franconia Notch Hotel Company acquired the hotel and some adjacent land in 1852. Within a year, it had opened a brand-new 110-bed facility, called the Profile House, and by 1853 had converted the original path up Mount Lafayette to a bridle path. Meanwhile, just a few miles south, a second bridle path had been established up Mount Lafayette in 1852, pretty much following the route of today's Old Bridle Path up the mountain. This second path supposedly replaced a crude footpath that had been established along Lafayette's twisting Agony Ridge two or three years earlier.

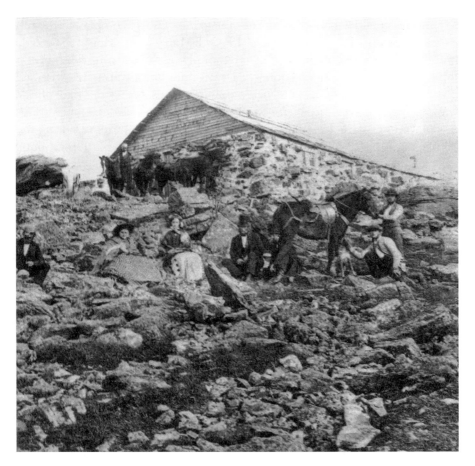

For a time during the mid-1800s, a stone shelter atop Mount Lafayette near Franconia Notch offered crude comfort to hikers and horseback riders alike. *Author's collection.*

Beginning at a clearing two and a half miles south of the Profile House, the bridle path "followed the only suitable route up the long, curving west spur" of the mountain, noted guidebook author Frank O. Carpenter years later. "The path is in all respects superior to the Profile path in ease, beauty of view and speed. One can...ascend Mt. Lafayette by this route without much fatigue, cheered by many views, and reach the junction of paths by Eagle Lake, almost as soon as the ordinary climber would reach the summit by the more direct and shorter but fatiguing and viewless Profile path."

Besides the two paths up Lafayette, new trails were also built around this time to picturesque Bald Mountain at the northern end of the notch, up Cannon Mountain and to Walker's Falls on Dry Brook, at the base of Franconia Ridge. The path up Cannon, then more usually called Profile Mountain, in all likelihood went from the Profile House complex to the top of the expansive ledges well above the Old Man of the Mountain profile and not to the actual high point of the mountain. "The ascent is somewhat difficult, requiring about two hours of wearisome climbing. But the extended prospect at the end of the journey amply compensates all the toils of the way," noted early editions of *Eastman's White Mountain Guide*.

The southern reaches of Franconia Notch were also bustling during the 1850s, thanks in great part to the building of the first Flume House hotel in 1848. Constructed near the entrance to the well-known Flume Gorge at the base of Mount Liberty, the Flume House was for many years operated by Richard Taft and his Flume and Franconia Hotel Company, builders of the Profile House. From this locale, a well-maintained path was constructed to the Flume Gorge from the hotel and adjacent Franconia Notch road, while across the way, the first path was built up to the prominent Indian Head profile on Mount Pemigewasset. And still farther south, not far from North Woodstock village, a path was established to scenic Georgiana Falls on Harvard Brook in 1859, just a year after they had been discovered, supposedly by a group of Harvard students. Meanwhile, there was further path-building taking place in other areas of the White Mountains during the 1850s.

There was the establishment of two new bridle paths up Mount Moosilauke, probably between 1857 and 1859. The first of these two paths climbed the mountain from Breezy Point in northeastern Warren and was the forerunner for the later carriage road built up the mountain. It was along this route that Mrs. Susan Little, the wife of local physician Dr. Jesse Little, made the first horseback ascent of Moosilauke in the summer of 1859. The second of the new bridle paths up the mountain attacked its slopes from the

north from the valley of Tunnel Brook and was described by Sweetser in his early guidebooks as a "long and tedious route." This was the forerunner of today's Benton Trail.

It was probably during the 1850s that a path up Moosilauke was also established from the vicinity of North Woodstock in the Pemigewasset River Valley. The so-called Little Path ran seven miles from the Woodstock-Warren road to the summit but was eventually extended two extra miles to North Woodstock village. This path existed in one form or another until the early 1900s, when its lower sections were obliterated by lumbering.

As a result of these new trails up the mountain, a summit hotel known as the Prospect House was built on the mountaintop by several local entrepreneurs and opened with great fanfare on July 4, 1860. Originally measuring thirty feet by fifteen feet, this summit structure would be enlarged several times over the ensuing decades and would alternately be known as the Summit House and Tip-Top House.

The construction of a bridle path and summit structure atop Mount Moriah near Gorham was another. Both these projects were undertaken in 1855 by John Hitchcock, the Claremont, New Hampshire native and proprietor of Gorham's Alpine House. The cramped summit building, measuring just sixteen by thirteen feet, was built of poles and logs hauled up the mountain by teams of horses. Hitchcock rented out a number of hardy Canadian ponies, stabled at the Alpine House, to take tourists up to the top of Moriah, and by all accounts, the summit house was well received by the tourist community, by some estimates rivaling Mount Washington in popularity for at least the first few years of its existence. Once a suitable carriage road up Mount Washington was completed in 1861, however, the Mount Moriah bridle path and summit house lost favor with the public, and within a few years' time, the upper section of the bridle path was no longer suitable for horse travel and the summit structure was in ruins. As noted in the 1863 edition of Eastman's *White Mountain Guide Book*, only the lower section of the bridle path, leading up to Mount Surprise, a subsidiary peak of Moriah, remained navigable by horse less than a decade after the trail first opened.

A third was located in the southern and eastern White Mountains, where early trails were established on Mount Chocorua, the Sandwich Range and Moat Mountain in North Conway. The first path up Chocorua, one of the most popular peaks in all of New England, was established in 1859 by an Albany, New Hampshire farmer and his son. This route began from the Hammond family's farm and approached the bare, rocky summit via its

White Mountains Hiking History

The earliest trail up iconic Mount Chocorua in the southern White Mountains dates back to 1859, when the Hammond family cut a path up the mountain's southeast ridge. *Photo by Chris Whiton.*

long southeast ridge. For several decades, the Hammond Path proved to be the most popular route up the mountain, but it was eventually superseded by alternate routes established later in the nineteenth century. On the Sandwich Range, the McCrillis Path to the summit of Mount Whiteface is regarded as the oldest route on the range. It was probably built in the late 1850s and began at the William McCrillis farm in Whiteface Intervale. In the first edition of his popular White Mountain guidebook, Moses Sweetser described the McCrillis path as being "somewhat difficult," with the last mile of the path passing "over long reaches of ledges and annoying rocks."

The Historic Fabyan Bridle Path

The so-called Fabyan (or Crawford) Bridle Path was the second path established up Mount Washington from the west and was built by legendary settler Ethan Allen Crawford and several hired men in the summer of 1821, just two years after construction was completed on the better-known (and still existing) Crawford Path.

The path appears to have followed, more or less, the route of the present-day Mount Washington Cog Railway. In *History of the White Mountains*, Ethan Allen Crawford recalled that in March 1821 he hired Esquire Stuart to "come with his compass and go into the woods and see if there could not be a better and more practicable way found to ascend the mountains." The two followed the Ammonoosuc River for about seven miles to the base of the mountain, then set course on a spur ridge up its steep slopes. "We could now ascend without much difficulty, and found there might be a road made, with some expense, sufficiently good so that we might ride this seven miles, which we thought would facilitate the visitor very much in his progress."

Work on the road and path commenced that summer "just before haying," and the path through the woods was finished by summer's end. Crawford did little of the actual work, however, as during the course of the summer he injured himself when he "nearly cut his heel cord off with his axe." His injury notwithstanding, Crawford that same summer accompanied Eliza, Harriet and Abigail Austin of Jefferson up Mount Washington in early September. They were the first three women to successfully reach the summit.

This view of Mount Washington from the west clearly shows the ridgeline climbed by the Cog Railway and, prior to that, the historic Fabyan Bridle Path. *Author's collection.*

The second Crawford Path, once built, quickly turned into Ethan Allen Crawford's preferred route up the mountain as he thereafter left guiding along the original Crawford Path to his father, Abel. It was via this crude, rough path that Ethan Crawford led many of his guests over the next decade or so. In the late 1820s, Crawford hinted at converting the path into a bridle path, but he never quite finished the job. It wasn't until after Horace Fabyan of Portland, Maine, purchased Crawford's inn and farm at Bretton Woods in 1837, and began operating out of the immediate area, that he converted

Crawford's second route up the mountain into a path suitable for horses. That made for two good bridle paths up the mountain from the west, with the conversion of the original Crawford Path having taken place in 1840.

A newspaper article from 1841, which describes a horseback ascent of the converted Fabyan Bridle Path in probably the first year of its existence, reveals much about the condition of the path. The article was penned by Nathaniel Peabody Rogers, who was among a party of nine people to make the ascent. Among the participants was Oliver Fabyan, brother of Horace Fabyan:

> *Our path lay through woods most of the way for six miles to the foot of Mount Washington. The growth was very large, some birches and pines the very largest we ever saw growing. Fires were burning about and had consumed the very soil and tree roots.*
>
> *We crossed the Ammonoosuck for the last time at the very foot of the mountain, and began our two-mile ascent. The guide ordered us to mind our distance, to bear forward as hard on the mane as possible, give the horses the entire reins, and take courage. We commenced our clamber and found it an awkward business to keep the saddle…We persevered—not talking much, for it was terribly steep and we had to mind our ways, crawling up precipices and between trees and around sharp rocks and among roots… The lessening trees at length announced that we were nearing the bare mountainside, which was an encouragement that we began to need, and our poor steeds more than we. They panted pitifully and looked as if they would implore us not to go any farther, though they seemed to understand what they were about as if they had been there before. The trees diminished till our heads were among their boughs, and kept lessening, preserving their entire form, till they were mere dwarfs—very ugly looking, with their stout trunks not more than a foot high and their sturdy, scraggy boughs…*
>
> *After we got on to the naked ridges the climbing was appalling. We did not dare look at it. Occasionally, as we cast an eye to right and left, across our hip we saw clear down the mountain a thousand feet or two, and so horribly precipitous that a false step would seem to have sent us to the very bottom.*
>
> *When we passed the most dizzy ridges our guide would hasten his ascent and sing his wild songs to divert our apprehension. We see him now—on his red horse, with our commissariat saddle-bags flapping against his sides—high above our head, turning the point of a cliff and singing "Some room to roam" at the top of his cry.*

White Mountains Hiking History

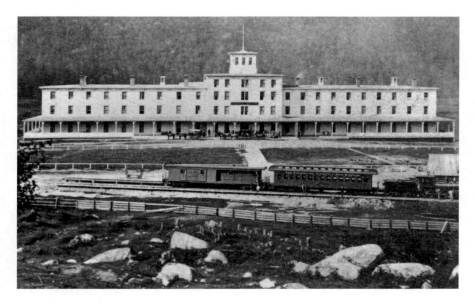

The second Fabyan House hotel at Bretton Woods, built in 1872, was named for Portland, Maine businessman Horace Fabyan, who was responsible for converting the Crawford's second footpath up Mount Washington into a bridle path. *Author's collection.*

According to Mount Washington historian F. Allen Burt, the Fabyan Path quickly became one of the most popular ascent routes up the mountain, attracting as many as one hundred people a day during the height of the summer tourist season. No doubt many of these riders were also guests at Horace Fabyan's inns located about seven miles from the base of the mountain. To better serve his clientele, especially those looking for an adventure to New England's high point, the hotelier opened a road from his inn at Bretton Woods to the present-day site of the Cog Railway base station. From there, riders followed the bridle path to the summit, climbing nearly four thousand feet in elevation in about two and a half miles. "Or approximately one foot in every three," wrote Burt in his seminal history, *The Story of Mount Washington.*

As popular as it was, however, the Fabyan Bridle Path was no match for Yankee ingenuity. By the late 1850s, New Hampshire native Sylvester Marsh, who made his fortune in Chicago and had settled in Littleton upon his return to the Granite State in 1863, had come up with the idea that there had to be a better way to climb Mount Washington than by horse or foot. His idea, which would come to fruition in the mid-1860s, was to construct a railroad that could ascend the mountain on an almost identical track as the bridle path.

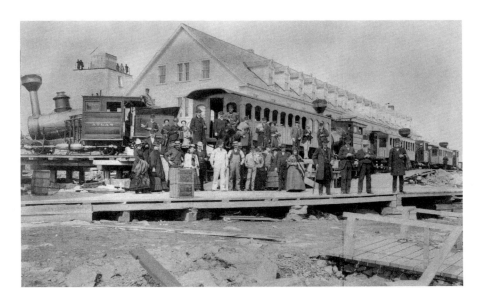

With the growing popularity of the Mount Washington Cog Railway, which transported visitors to the mountaintop's Summit House hotel, use of the Fabyan Bridle Path gradually diminished. *Author's collection.*

The novelty, relative comfort and speed of the train ride up the mountain won over the growing number of visiting tourists, leaving both the Fabyan Bridle Path and original Crawford Path bridle route to only the hardiest of souls. Among them, apparently, were two men who, in August 1901, descended from the summit of Mount Washington to the Cog Railway base area by way of the then long-abandoned Fabyan path. As the summit newspaper, *Among the Clouds*, reported, "It is rare nowadays that any one attempts the descent of the mountain by this route, but these gentlemen report that the views to be had are admirable, comparing favorably with those from more frequented paths."

Horseback Ascent of the Crawford Path

Many present-day explorers of Mount Washington and the peaks of the southern Presidential Range probably have some knowledge of the historical significance of the eight-mile-long Crawford Path, which leads from the top of Crawford Notch to the 6,288-foot summit of New England's highest peak. Originally constructed in 1819 by Abel and Ethan Allen Crawford, the trail has been in continuous use ever since and over the last century has borne the soles of hundreds of thousands of hikers' boots.

What many of these trampers may not be aware of, however, is that the Crawford Path was once one of the most popular horseback ascent routes in the White Mountains, particularly in the years before the Cog Railway was constructed up the western side of the mountain and the Mount Washington Carriage Road was built on the mountain's eastern slopes. Horseback ascents via the Crawford Path were, in fact, daily events for a number of summer seasons, and although the route up Mount Washington was rough and fraught with potential hazards, riders could make the journey in relative comfort.

White Mountains Hiking History

The First Horseback Ascent of Mount Washington

It was in 1839 and 1840 that the pioneering Crawford family decided to convert their original footpath up the mountain into a bridle path. One of Abel Crawford's younger sons, Thomas, along with hired hand Joseph Hall are credited for much of the work making this bridle path a reality. Thomas J. Crawford was one of Abel's eight sons and for nearly a quarter century (1829–53) operated the family's Notch House, a small inn situated a short distance from the rugged Gateway to Crawford Notch.

At first, the bridle path section of the Crawford Path went only as far as the summit of Mount Clinton, where the Crawfords had also constructed a crude overnight shelter. Within a short time, however, it was decided to extend its length all the way to the summit of Mount Washington, some eight-plus miles distant from the top of Crawford Notch.

Appropriately enough, the first person to ride horseback all the way from the notch to the top of New England's tallest peak was Abel Crawford, who by then was seventy-five years of age. This trip took place in August 1840

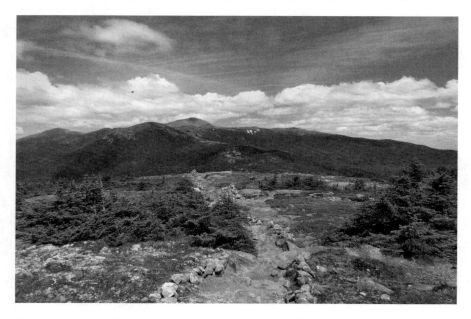

Negotiating the rough-and-tumble course of the Crawford Path could not have been easy for either horse or rider. In total, the path runs 8.5 miles, with nearly five thousand feet in elevation gain from start to finish. *Photo by Chris Whiton.*

and has been best documented by Bostonian Dr. Charles T. Jackson (1805–1880), who at the time was heading up the first geological survey of New Hampshire. (A few years later, in 1848, a four-thousand-foot summit along the southern Presidential Range would be named for Dr. Jackson by botanist William Oakes, author of *Scenery of the White Mountains*.)

"A horsepath had just been completed to the summit of the mountain, and we were enabled easily to make our ascent, carrying in safety all the instruments for the observations which we proposed to make," wrote Jackson in his 1844 geological survey report to the state legislature. "Abel Crawford, the veteran guide of the mountain, accompanied us, and leading our party, was the first man who ever rode to the summit of Mount Washington."

"Entering a narrow footpath leading through the forest, we rode to the summit of Mount Clinton, a bald mountain having no other forest trees upon it save a few stunted and dead spruces, which were killed by fire," wrote Jackson. Stopping frequently along the way to take barometrical measurements and record other observations, Jackson reported that the climbing party continued on its way toward Mount Washington, passing over the summits of Mounts Pleasant (today's Mount Eisenhower) and Franklin at about 9:30 a.m. and 10:00 a.m., respectively. "On Mt. Franklin," he wrote, "all traces of vegetation, excepting plants of an Alpine character, disappear." He observed also that the rocks along the ridge "consist entire of granite and gneiss, with occasional veins of quartz."

A bit farther along, after passing by Mount Monroe, the party approached the area known as the Lakes of the Clouds, the longtime site of the Appalachian Mountain Club's backcountry hut of the same name. "Several ponds and springs occur near this spot," noted Jackson, "and travelers generally stop awhile there to refresh themselves before ascending to the summit of Mount Washington, which is in full view and presents its rough and rocky escarpments."

Shortly before noon, at about 11:45 a.m., Crawford, Jackson and the rest of their traveling party finally reached the summit on horseback, "a feat quite novel, this being the first time that it has been affected," wrote Jackson. Once at the summit, more observations were taken, the most interesting having to do with determining the summit's elevation. As best as Jackson could ascertain, the height was 6,228 feet above sea level, or 60 feet lower than today's generally accepted height of 6,288 feet.

While Jackson, Crawford and several others in the party returned to Tom Crawford's Notch House that same day, two of the geologists' scientific team spent the night on the mountain in a crude shelter not far from the summit.

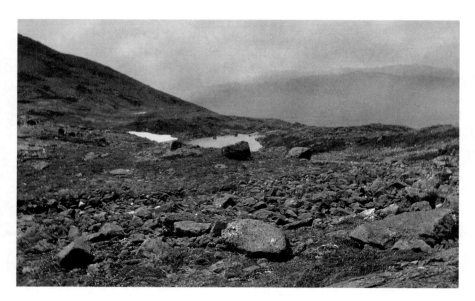

The Lakes of the Clouds on Mount Washington's western slopes are seen here prior to construction of the Appalachian Mountain Club's hut in 1915. The lakes have long been a resting place for summit-bound hikers and riders on Crawford Path. *From* Our Mountain Trips, Part II: 1909–1926 *(2007)*.

These men, Moses B. Williams and Eben Baker, continued making hourly observations the day of the ascent and during much of the following day. Williams and Baker eventually joined Jackson back at the Notch House the next evening.

Ever grateful for the amount of toil put into converting the Crawford Path into a route suitable for horse travel, Jackson added, "Travelers should thank the Crawford family for having made this ascent so easy and agreeable, for now any person who knows how to ride, may safely travel on horseback over their path to the very highest point in New England. I doubt not that this circumstance will induce a greater number of persons to ascend the mountain."

Although the month and year of this historic ascent of Mount Washington have been noted in numerous books and articles for more than 160 years, the actual day and time of the trip have rarely, if ever, been reported. Fortunately, Jackson's survey report includes an appendix in which he lists the dates and times of all his survey observations, and because of that, we know exactly when Abel Crawford's horseback ascent took place, the date being August 21, 1840.

One Final Horseback Ascent

As mentioned previously, for a number of years, the Crawford Bridle Path was used extensively during the summer and fall tourist seasons, primarily by guests of the Crawford family's various inns and hotels in the immediate vicinity. But the construction of a competing bridle path on the mountain (the Fabyan Bridle Path), the building of the Glen Bridle Path from Pinkham Notch and the later construction of the Cog Railway and Mount Washington Carriage Road all led to the slow and steady decline of the Crawford Path as a popular horseback ascent route.

In fact, the Crawford Path seems to have lost favor even with hikers, as evidenced by some guidebook descriptions from the late 1800s. In his 1882 book, *Walking Guide to the Mt. Washington Range*, author William Pickering noted that although it is a "well-marked path, travelled every pleasant day by parties during the summer," the path was also "in many places obstructed by fallen trees." Pickering added that although the path was once popular as a bridle route to the summit, it had been many years since anyone had used it for that purpose.

It is surprising, therefore, to know that fifty years later, on September 1, 1932, one final horseback ascent *was* made up the Crawford Bridle Path, a feat that had not been accomplished in several generations. The riders were four individuals affiliated with the recently formed Littleton Riding Club, and despite less than ideal conditions along the exposed ridge of the southern Presidentials, they managed to successfully negotiate their way to the fog-bound summit in slightly less than six hours.

According to local news accounts of this momentous occasion, the four riders—two men and two women—were hailed by summit officials and guests as "pioneers in equine mountain climbing," with the *Littleton Courier* newspaper going so far as to claim that "probably no attempt to climb Mount Washington has attracted such widespread interest." On the day of the trip, the paper noted that if the riders were successful in reaching the top of Mount Washington, "it will be the first time that horses have been over the [Crawford] path for the past half century."

The day began early for all concerned as the riders and their four mounts were transported to the base of the Mount Clinton on the morning of Thursday, September 1, and the quartet set out up the Crawford Path at 8:15 a.m., "well supplied with provisions for themselves and their horses," along with extra clothing. The group included Mrs. Blanche K. Eames, wife

of Littleton businessman John B. Eames; Miss Doris Lunderville, also of Littleton; Elmer Ness, head of the Riding Club; and his capable assistant, twenty-year-old John Challon, described as a native of New Jersey and a skillful horseman, both as a rider and trainer.

The initial part of the journey was "comparatively easy," reported the Littleton newspaper, but by the time the riders passed over Mount Clinton and were on their way to Mount Pleasant, they were walking through the clouds in fog so dense that visibility was limited to just a few feet and clouds so moist that all concerned were quickly "drenched to the skin." As any hiker who has encountered such conditions above the tree line readily knows, progress can be slowed to a crawl as one searches for the correct way to proceed. At times, the riders had to rely on a single member of the party to walk ahead to the next cairn or trail marker and then lead the others to it.

Despite what the newspaper termed the "eerie surroundings" encountered by the party, and the rough-and-tumble nature of the Crawford Path, with its uneven and treacherous footing, the horses "fared remarkably well" as they proceeded toward Mount Washington, albeit at a snail's pace. That's not to say that the trip was without its share of unpleasantness. Several times, the horses broke through log bridges erected over ditches and ravines traversed by the path. In each instance, the horse and rider would inevitably be deposited in the water several feet below.

As the riders neared the base of Mount Washington's summit—passing first by the Lakes of the Clouds, where they encountered a number of hikers who were "astounded to find the mounted trampers in such a desolate spot"—the fog was even thicker. For a time, the Littleton party became quite disoriented and mistakenly headed in the wrong direction as the foursome passed over one of the mountain's flat, featureless "lawns" just south of the summit cone. Instead of finding themselves on the Crawford Path, which provides the most direct route to the summit from Lakes of the Clouds, the riders stumbled onto the Glen Boulder Path and Davis Path, both well to the east of their intended route.

Once they realized their mistake, the riders doubled back in the fog and eventually regained the Crawford Path, but the misdirection took its toll on all involved in the horseback ascent. The wearisome mile-long climb to the mountaintop, a fatiguing chore even under the best of circumstances, proved that much harder. And even though one of the horses lost a shoe in the final push to the summit, the animals and their passengers "withstood the unusual task admirably," reported the newspaper, and as the party reached the top, the Summit House hotel emerging unexpectedly out of the thick fog, surprised guests greeted the four riders with cheers and congratulations.

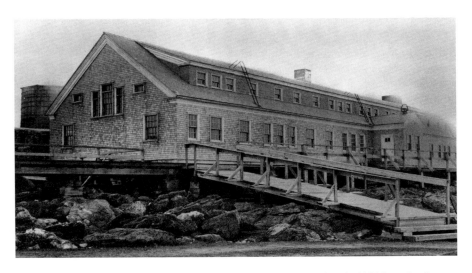

Upon arriving at the summit of Mount Washington after their historic 1932 horseback ascent, members of the Littleton Riding Club were greeted by management and guests of the third Summit House. *Author's collection.*

Atop New England's grandest peak, the adventurers were treated as conquering heroes, and a grand reception courtesy of Cog Railway president Colonel Henry Teague was held in their honor. Afterward, the women riders returned to the base of the mountain by train, and by late afternoon, both were back in Littleton, with the forty-six-year-old Mrs. Eames even spending a portion of the night at her usual post working the candy counter at her husband's local movie house, the Premier Theater. (Mrs. Eames, who lived to seventy years of age, dying in November 1956, had an interesting background. She was born in Canning, Nova Scotia, in 1886 but moved to the United States while still a young child after being adopted by a married couple from Montpelier, Vermont. She later married John Eames in Barre, Vermont, moved to Littleton and was well known as a talented concert pianist, attending the Boston Conservatory of Music and also studying piano in New York City for several years. Besides performing with several large philharmonic orchestras along the East Coast, she played regularly at her husband's downtown movie theater in Littleton during the silent film era, as well as in many community musical productions.)

As for Ness, Challon and the four horses, they descended the mountain via the Auto Road, and once at the Glen House in Pinkham Notch, they returned home by truck, arriving back in Littleton sometime after midnight after an exhausting but triumphant day that has never again been duplicated.

Allen Thompson

Early White Mountain Guide

White Mountain lore is full of many colorful and fascinating characters. To name just a few, there are pioneer settlers such as Abel Crawford and his son, Ethan Allen Crawford, inimitable Dolly Copp of Pinkham Notch fame and tireless late nineteenth-century trail-builders Charles Lowe, Laban Watson, Eugene Cook and J. Rayner Edmands. While much has been written of these legendary White Mountain figures, the same cannot be said of Allen "Old Man" Thompson, a remarkable and colorful character in his own right.

Allen Thompson (1814–1909), though never a trail-builder in the same vein as Lowe or Watson, was certainly one of the most competent mountain guides of the 1800s. A longtime Bethlehem resident, Thompson was a legendary hunter and guide who knew the trackless western side of the mountains as well as anyone of his day. His forays into the wilderness also took him elsewhere in the Whites, as well as among the lakes of Maine and Canada.

Thompson was born in Woodstock, Vermont, on January 23, 1814, but at a young age left home and joined a tribe of Mohawk Indians in the northern part of New York. Under the tutelage of the tribe's leader, who took a quick liking to the "young pale-face," Thompson learned the ways of the Native Americans and became an expert hunter and fisherman.

According to Thompson himself, writing in the *Among the Clouds* tourist newspaper in 1877:

WHITE MOUNTAINS HIKING HISTORY

My real life as a hunter began in 1831, when I was seventeen years old. My parents having died when I was two years old, I was given to a man to be brought up, but he and I failed to agree and I became restless and determined to seize the first opportunity for gaining my liberty. Well, it came through an Indian chief. I went to a Vermont town to see a horse-race, and there I met a Mohawk Indian chief named Wanawah, who had come to the race to sell baskets and skins. When he asked me to return with him I wasn't long in making up my mind to do so. Wanawah was a grand noble fellow, who ruled the remnants of the Mohawk tribe. He had received a good English education and he became not only my friend but my instructor, teaching me all manner of woodcraft.

Thompson went on to say that he lived two years with the Indians, and although "it was pretty rough sometimes, they were the happiest years I had ever spent, and I thoroughly enjoyed the hunting."

Thompson eventually made his way to the White Mountains, settling in Bethlehem in about 1835. Here, he married, started a family (having eight children with his first of two wives) and became a well-known trapper, hunter, fisherman, guide and surveyor. Among his clients was noted nineteenth-century Swiss explorer and scientist Louis Agassiz, who reportedly

ALLEN THOMPSON
"OLD MAN THOMPSON"
January 23, 1814 January 24, 1909
The Last Great Guide and Trapper of the White Mountains
Picture taken at the age of 94 years—Holding one of his bear traps.

Allen Thompson, pictured here at ninety-four years of age, spent decades exploring the peaks and valleys of the region and guiding adventurous visitors through a mainly trackless forest. *From* "Old Man" Thompson: A White Mountain Story of Infinite Thought Value *(1911).*

"always hired Allen as his guide in his journeys in the mountains." Perhaps it's no coincidence that Thompson, in at least his later years, lived in a small cottage running along the northern base of the mountain that to this day bears the name of Aggasiz.

Another old tourist newspaper from the grand hotel era of the late nineteenth century offers perhaps the best glimpse of Thompson in his true element—the backwoods of the western White Mountains. In the "Echo Explorations" series of adventures published during the summers of 1879 and 1880 in the Bethlehem-based *White Mountain Echo and Tourist's Register*, it was Thompson who frequently "guided" writer Benjamin A. MacDonald to places such as the trail-less Zealand River Valley and, in one memorable trip, up onto Garfield Ridge, down into the Franconia Brook valley and then back up onto the Twin Range, almost the entire distance being covered without the benefit of a marked path or trail.

Writing about their 1879 venture into the Zealand area, MacDonald recalled the ease in which "Old Man" Thompson, as he liked to call him, made his way along through the woods and along the streambed of the Zealand River:

> *As is common to all these mountain streams or rivers, the bed was filled with huge masses of rock of every imaginable size, shape and color. The only way to progress is to leap and stride from rock to rock, sometimes securing a firm foothold, and at others slipping from rough jagged edges into the water beneath…Thompson seemed to treat the difficulties of the road with perfect indifference. He scarcely ever slipped, but my unlucky star was ever in the ascendant. I would make a desperate dash for a rock about five feet away, and, on reaching it, would find it anything but the sure foundation I had anticipated.*

As the pair continued upriver, heading for remote Zealand Pond, where they intended to camp for the night, MacDonald wrote that they were "following an old deer path, through swamps and over fallen stumps of trees and into brooks, until I commenced to despair of ever reaching the Pond. The perspiration poured off me in streams, and my clothing was saturated. But the old man kept on ahead as if nothing unusual was occurring; in fact, I think he was more 'at home' than if he had been in Bethlehem."

In early August 1882, Thompson was a key participant in another epic trek into the White Mountain wilderness when he was employed as a "woodsman" on the so-called Scott-Ricker expedition to the remote Twin-

White Mountains Hiking History

A number of Allen Thompson's most ambitious wilderness treks were written up in the Bethlehem summer newspaper, the *White Mountains Echo and Tourist's Register.* Of particular interest are writer Benjamin MacDonald's accounts of journeys in 1879 and 1880. *Mount Washington Observatory Collection.*

Bond Range. Organized by Appalachian Mountain Club councillor of improvements Augustus E. Scott, the seven-day adventure confirmed the feasibility of constructing a path over the ridge, and by year's end, the first section of the trail had been completed.

Having learned the ways of the Indians, Thompson was, of course, well versed in the ways of hunting and fishing, with one writer calling him "an authority on animal psychology, sharpshooter and geographer of track and trail." In another article appearing in the July 19, 1879 edition of the *White Mountain Echo,* Thompson was quoted thusly: "As to the amount of game I have killed, why, thirty years ago deer used to be as plentiful in Bethlehem as sheep. I have often seen the deer feeding in the midst of the cattle when the latter have had salt fed to them. Yes, sir, I used to kill forty deer a year then, which average I kept up for fifteen years or more. Of bears I used to kill one or two every year, while as for red foxes, there was hardly a year I shot less than seventy or eighty, and I remember that one year I shot one hundred and fourteen, but this, of course, was exceptional."

Legend also has it that Thompson killed the last wolf in the White Mountains, although it's difficult, if not impossible, to verify this claim. Elizabeth Churchill, writing in the small tourist book *Bethlehem and Its Surroundings,* noted that a "wolf eighty pounds was trapped on Mt. Agassiz" in 1868. She did not say whether it was Thompson who caught the wolf, but in the same paragraph, she alluded to the fact that Thompson is an "authority on the habits and haunts" of the wild and that if visitors desire to "interview a bear or a wildcat, it may be possible to secure that pleasure by taking into council one Allen Thompson."

Thompson lived a long life, especially by nineteenth-century standards, and was a week shy of ninety-five years of age when he passed away on January 17, 1909, at his daughter's home in Bethlehem. According to the *Littleton Courier* of January 21, 1909, "Mr. Thompson enjoyed remarkable vitality and health, having been strong and vigorous in unusual degree for one so advanced in years; until a week before his death, when he sustained a bad fall down stairs, dislocating his shoulder."

Thus ended the life of one of the White Mountains region's most tireless and resilient yet little-known explorers of his time.

The Trackless Zealand River Valley in 1879

The Zealand River Valley in the heart of New Hampshire's White Mountains is the perfect showcase of nature's ability to restore itself in the face of humankind's often-destructive tendencies. This was an area of the forest that was ravaged by both heavy timber harvesting and forest fires, and as recently as the 1920s, it was described in guidebooks as "a desolate country, little visited except by fishermen and berry pickers."

The remarkable decades-long recovery of the landscape in and around Zealand Notch has transformed this "desolate" wilderness into one of the most frequently visited areas within the boundaries of the White Mountain National Forest, with the Appalachian Mountain Club's Zealand Falls Hut long a favored destination of hikers.

As the main routes into, and the scenic qualities of, the Zealand area can be found in any number of present-day hiking guides and travel books, it's not necessary to relate them here. It is worthwhile, however, to journey back more than 125 years to the late 1800s and pay a visit to the Zealand region through the words of a writer, Benjamin MacDonald, who saw the land at its primeval best.

MacDonald's account is from August 1879 and tells of his excursion into the Zealand area with legendary guide Allen Thompson of Bethlehem. This account first appeared in the *White Mountain Echo and Tourist's Register*, a summer newspaper published in Bethlehem, and describes a multi-day camping trip that included visits to Zealand Pond, Thoreau Falls and Ethan Pond. At the time of this trip, lumber baron James Everell Henry's logging

crews were still a few years away from invading the Zealand area (then known as New Zealand), and several of the natural landmarks described by MacDonald either bore different names than today or were named by the writer in the course of this trip.

After setting out from Bethlehem and preparing their packs for the long journey up into Zealand, MacDonald wrote, "Our way lay directly across the Ammonoosuc [River], to a path just barely visible between the thick bushes that hung over the waters' edge. To my eyes there was no trace of a road, but the old man [Thomson] did not hesitate a moment, and splashed across the river and pushed aside the bushes with as much apparent familiarity as if he had travelled the road every day."

After passing by the rather obscure Bethlehem town line ("it was anything put palpable to me," wrote MacDonald), the trampers continued south until "[a]bout a mile and a half or two miles from our starting point we came to the New Zealand Stream. Here our course lay up the river bed." Following a short lunch of fat pork and freshly caught trout, MacDonald and Thompson soon came upon "a series of cascades that were very pretty and pleasing, but about a mile beyond these I came to what Thompson called 'The Falls.' Directly in front of me rose a wall of rock about fifteen feet high, dark in color and irregular in shape and outline, with mosses and ferns clinging to its rugged sides, the whole forming a beautiful screen to three charmingly picturesque waterfalls behind…I have taken the liberty to name them Hastings' Falls, after a young engineer who is well known in this district, but who is now unfortunately a resident of 'that bourne from whence no traveler returns.'"

Despite oncoming weariness, MacDonald trudged through the forest, trying his best to keep up with the ageless Thompson, who by then was well into his sixties:

> *The surroundings—trees, foliage, everything—was enchanting, but Thompson was inexorable. Every time I would stop, if even for an instant, I would see the old man forging ahead, as if scenery and Nature had no charm for him, but only the one single purpose he had in view of reaching New Zealand Pond that night. Accordingly, however reluctant I might be, I was bound to follow.*
>
> *The perspiration poured off me in streams, and my clothing was saturated. But the old man kept on ahead as if nothing unusual was occurring; in fact, I think he was more "at home" than if he had been in Bethlehem. At last I could stand it no longer; the pain was unendurable,*

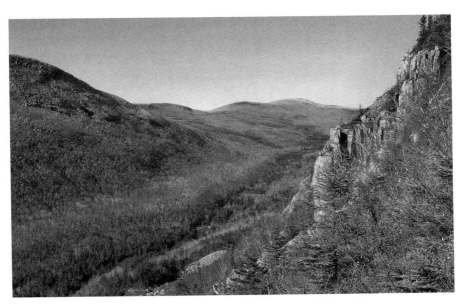

Remote Zealand Notch, as viewed from the top of Whitewall Mountain. *Photo by John Compton.*

and the pack upon my shoulders seemed to weigh a ton. I called out that I would not budge another inch, that I could not move a foot farther. I might as well have expostulated with the Sphinx. The old man pursued the even tenor of his way perfectly unconcerned….Never shall I forget the feeling of relief I experienced when Thompson called out: "Here we are! How's this for a camp?"

On the second day of their journey, the trampers departed Zealand Pond and made their way through Zealand Notch. "It is variable in width, its greatest span being at its southern outlet, where it is over 400 feet, while at its narrowest portion it is from 300 to 350 feet," noted MacDonald. "The Notch extends from the beginning of [the] southern outlet of the Pond to its junction with the Pemigewasset, a distance of about three miles. There is a natural shelf-like road-bed for a railroad throughout the entire pass, varying from twenty-five to thirty feet in width. There are occasional small ravines, but none that could not be easily bridged over. As Thompson assured me—and I must say, from what I saw, the old man's judgment seemed correct—'A railroad could easily be constructed clear through from Sawyer's River to the Ammonoosuc by way of this Notch.'"

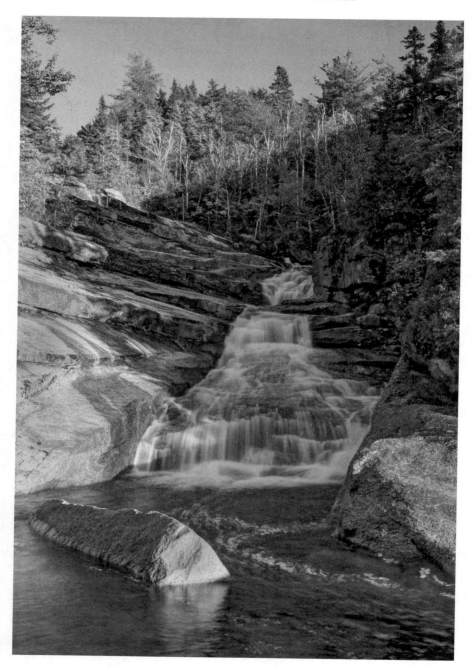

In the course of their Zealand Valley trek, MacDonald and Thompson visited Thoreau Falls along the North Fork of the East Branch of the Pemigewasset River. "The scene is simply magnificent, and none except those who have visited the spot can conceive its loveliness," raved MacDonald.

(That, of course, is exactly what happened less than a decade later when Henry established the Zealand Valley Railroad and constructed a portion of the line right through Zealand Notch.)

The trampers spent their second night camped alongside the North Fork of the East Branch of the Pemigewasset River, then headed upstream, where they soon arrived at a cascade at the base of Thoreau Falls. "It does not compare with the Silver Cascade in the White Mountain [Crawford] Notch, or with others in the mountains for height," noted MacDonald, "but it has a simple, quiet beauty that cannot fail to impress all beholders with admiration. The scene was very beautiful. I could have stayed for hours, had time permitted, but I was compelled to catch one fleeting glance and then pass on. Before we left, however, we concluded to name this the Echo Cascade."

Continuing upstream, MacDonald and Thompson soon reached the main falls:

> *The road was straight before us, rising higher and higher, over innumerable small waterfalls, pretty and enticing in themselves, until at last the rush and roar of something greater than I yet had witnessed became distinguishable. A few rods more and the grand falls themselves were in view. They are at least a hundred and fifty feet high but are really rapids rather than falls. The rocks rise up in an almost vertical line and the stream rushes over in one corner, to my right, as I stood facing the falls. At the summit the water has a clear descent of about twenty feet and then keeps on down a natural stairway for about seventy or seventy-five feet, when it makes an abrupt curve and descends to the base. It is a mass of foam from where the water first strikes on its way down to the bed of the stream. The scene is simply magnificent, and none except those who have visited the spot can conceive its loveliness.*

From Thoreau Falls, MacDonald and Thompson continued through the woods to Ethan Pond, where they camped for the night on its shores. "We found it very difficult to obtain wood, as the Pond is a favorite ground for fishermen, who always camp where we did, but, after some time we secured enough to keep a small fire going during the night and, tea over, we lay down for our last night in the woods," wrote MacDonald.

They concluded their four-day journey by spending the following morning climbing in the rain up and over Mount Willey and then down into Crawford Notch. After a brief respite and late breakfast at one of the

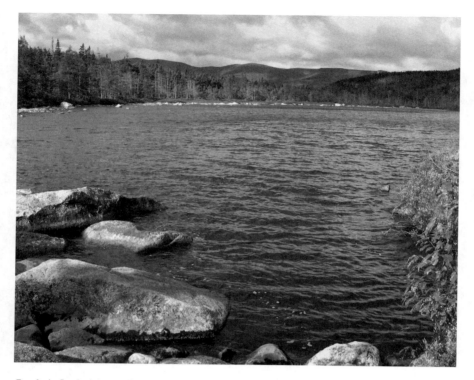

On their final night out in the woods, MacDonald and Thompson camped near Ethan Pond at the western base of Mount Willey. *Photo by Steven D. Smith.*

Portland & Ogdensburg Railroad section houses situated along the tracks as they passed through the notch, MacDonald and Thompson journeyed by foot to the Crawford House, where they planned to board a train for the ride back to Bethlehem.

"Taking seat on the platform of the station, we lit our pipes and patiently awaited the arrival of the next train, which unfortunately was not due for an hour. While sitting on the platform a thought suggested itself to me, and I asked Thompson if we were not facing directly opposite Thoreau Falls?" wrote MacDonald.

"Certainly, we are," he replied. "Do you see that ravine between those two mountains directly opposite to this station? Well, sir, if you keep straight on that line between those two mountains for seven miles, you will come directly to the falls."

"This was what had suggested itself to me," responded MacDonald. "A bridle path can be made with little expense direct from the Crawford

House to these falls and thus another beautiful feature of the mountains made accessible to the world." Though no such bridle path was ever built, a footpath was eventually constructed up and over that same ridge, conveniently connecting Crawfords with AMC's Zealand Falls Hut.

Despite being tired, hungry and footsore, MacDonald concluded his piece by writing, "I felt happy in my reflection that if by any chance I should be the means of drawing attention to hidden features in the wilderness that in the future may afford pleasure to the humblest of God's people, I shall at least have accomplished something for which I am thankful, and my journeyings in the wild forest will not have been entirely unproductive of good."

As we reflect on his writing now, more than 130 years later, I think MacDonald would be pleased to know that he has also provided readers of the twenty-first century with a unique look at a revered area of the White Mountains that would soon thereafter be forever altered by the incursion of J.E. Henry's lumberjacks.

Legacy of the North Woodstock Improvement Association

Hikers today are certainly familiar with the many clubs and organizations that do such a great job keeping the extensive White Mountains trail system in good order. The Appalachian Mountain Club, formed in 1876, is probably the best known of these organizations. Others include the Randolph Mountain Club, the Wonalancet Outdoor Club, the Chatham Trails Association, the Waterville Valley Athletic and Improvement Society and the Chocorua Mountain Club, to name just a few.

One hundred years ago, there was another such organization in the upper Pemigewasset River Valley, and although this club was only in existence for a few decades, its work continues to benefit today's hikers.

The North Woodstock Improvement Association (NWIA) was founded in 1897 primarily by the growing legion of summer residents of the area who had a strong interest in hiking and building new trails. These members of North Woodstock's summer cottage community included individuals such as Frank O. Carpenter; Wesleyan University professors Karl Pomeroy Harrington and Herbert W. Conn; Edmund Alden of Brooklyn, New York; and a Miss Cummings of the Wesleyan faculty.

As stated in their occasionally published short guidebooks to the hiking paths in the Pemi Valley, titled *A Little Pathfinder to Places of Interest Near North Woodstock*, the NWIA's primary purpose was "rendering more accessible the many points of interest in this part of the Pemigewasset Valley. It has endeavored to place in condition the old paths, to open new routes and outlooks, and to mark them with sign-boards." These short guides, which are

Frank Carpenter, pictured here on the far left, accompanies a group of explorers headed for Lost River Gorge on August 10, 1908. *Lost River Reservation.*

treasured finds nowadays, were published sporadically during the NWIA's short-lived existence, with the fourth (and I believe final) edition appearing in 1921.

While Edmund Alden and Ms. Cummings were apparently the "early leaders" of the club, according to historians Guy and Laura Waterman, much of the actual fieldwork accomplished by the organization can be traced to two primary individuals: Frank Carpenter and Karl Harrington.

Carpenter was a teacher at English High School in Boston and a member of North Woodstock's summer cottage community and had a special affinity for nearby Franconia Notch, in particular the western slopes of Franconia Ridge. Besides exploring all the existing trails on the ridge, Carpenter made an effort to establish new routes and reestablish old routes, such as the lost Old Bridle Path up Mount Lafayette. In 1898, he published a guidebook, *Franconia Notch and the Pemigewasset Valley*, that covered both the trails in the Pemi Valley and the many hotels and inns that had sprouted up in town after the Boston & Maine Railroad extended its line from Plymouth to North Woodstock in 1883.

Besides being a founding member of the North Woodstock Improvement Association, Carpenter also belonged to the AMC, for whom he served as councillor of explorations in the later 1880s. In his first report to the club, appearing in the December 1887 issue of *Appalachia*, it comes as no surprise

that much of his first summer at the post was spent organizing scouting trips up and down the Pemigewasset Valley. In ensuing issues of *Appalachia*, Carpenter wrote detailed accounts of his visits to the various peaks of the Benton Range (Black, Sugarloaf, Blueberry and Hog's Back among them); his traverse of the long, trail-less Mount Carr range; and of his bushwhack adventures up Russell Mountain near Lincoln and Woodstock, as well as the ridge south of Mount Flume to the "Whale-Back."

In August 1901, Carpenter supervised construction of a new path up Mount Liberty from the west. This path superseded an older path that had fallen victim to logging activity on the lower slopes of the mountain. There were actually two branches of the path, one from North Woodstock and Lincoln and one from head of the famous Flume Gorge near Franconia Notch. Carpenter wrote that David Gentiss of North Woodstock did most of the work in establishing the new trails up Liberty but was aided by half a dozen other volunteers, including Carpenter. That same summer, Carpenter also oversaw efforts to reopen the Old Bridle Path up Lafayette, which had opened and closed a number of times over the past few decades.

The Watermans, in their monumental history of hiking in the Northeast, *Forest and Crag*, noted as well that in 1897, Carpenter cut a trail up the west-running ridge of Mount Lincoln on Franconia Ridge. Unfortunately, this path, like so many of the others that Carpenter worked on during this period, was rendered useless soon thereafter by ongoing logging activity in the notch. To this day, however, that ridgeline is known as Carpenter or Carpenter's Ridge.

Although he was born near New Hampshire's seacoast and spent most of his life in Connecticut, no one was more at home in the White Mountains than Karl Pomeroy Harrington, another longtime summer resident of North Woodstock and a tireless hiker and trail builder. He, too, was a founding member of the North Woodstock Improvement Association.

A Latin scholar, a longtime professor at Wesleyan University and a native of Great Falls (Somersworth), New Hampshire, Harrington owned the red-roofed chalet known as Quiseana high up on the north-facing slope of Parker Ledge just south of North Woodstock village. From this summer home, which he had built in 1894, he enjoyed a spectacular view toward Franconia Notch. As Carpenter noted in his 1898 guidebook, "Quiseana is higher than any other cottage in the valley and the splendid panorama of mountain range and river valley seen from its piazza is most noble and inspiring."

Along with fellow NWIA members, Harrington helped lay out and maintain the club's many paths in the vicinity of North Woodstock. Although many

of these paths no longer exist, there were enough of them in the early part of the twentieth century to justify the club periodically publishing its small guide to these trails. Even though you won't find Harrington's named mentioned in the various editions of *A Littler Pathfinder*, you can be certain that he helped edit and prepare the text.

Harrington's interest in the mountains of northern New Hampshire began at an early age. He was just nine years old and on a family excursion to Colebrook and the remote Dixville Notch region when his uncle, Leonard Harrington, coaxed him into climbing to the top of precipitous Table Rock, which overlooks the narrow mountain cleft. In

Karl Pomeroy Harrington was a longtime summer resident of North Woodstock and a tireless mountain explorer and trail-builder. *Author's collection.*

his autobiography, privately published more than twenty-two years after his death, Harrington called the Table Rock ascent a "thrilling adventure for a small boy who had never done any mountain climbing, but perhaps an omen of my subsequent devotion to that pastime."

A more extensive visit to the Whites occurred eleven years later when Harrington, then a Wesleyan student, and a college friend spent six weeks in the summer of 1881 exploring on foot the wilds of New Hampshire. Their four-hundred-mile walking journey, which began in Springfield, Massachusetts, took them up the Connecticut River Valley as far as Bellows Falls, Vermont. From there they crossed into New Hampshire and eventually made their way as far north as West Stewartstown and then Coaticook, Quebec. Along the way, they hiked to the summit of Cannon Mountain and dined at the Profile House. They also twice climbed Mount Washington

(once along the Crawford Path and once along the carriage road); strolled through the Flume Gorge; spent at least one night at the Willey House in Crawford Notch, the Tip-Top House on Mount Washington and the Glen House in Pinkham Notch; and ascended Mount Chocorua via one of its earliest paths, the Piper Trail.

In what must have been during his early years summering in North Woodstock, Harrington, fondly known as "K.P.H." to his friends, made his first excursion into the untamed Pemigewasset Wilderness sometime before James Everell Henry's loggers invaded the primeval forests of this region. Accompanied by Carpenter, the pair bushwhacked their way up Mount Bond from the Franconia Brook valley. Then, from Bond, they scratched and clawed their way east toward a camp near Thoreau Falls. They finished their journey by tramping out by way of Willey (now Ethan) Pond and Crawford Notch.

In 1919, Harrington, then approaching sixty years of age, joined the Appalachian Mountain Club, and within just a few years, he was serving as AMC's councillor of trails. During the three years (1923–25) that he held down this important post, Harrington oversaw the completion of several key links in the ever evolving White Mountain trail system, including the construction of the Bondcliff Trail from Mount Bond to the East Branch valley; the trail across the wild and rugged Mahoosuc Range in the northeastern Whites; and the building of the Shoal Pond Trail, conveniently linking the Carrigain Notch area with the Ethan Pond region. He also worked in establishing the first through trail along the Kinsman Range to the west of Franconia Notch. Fittingly, two natural features along the Kinsmans bear family names. Harrington Pond, a remote mountain tarn lying in the shadow of South Kinsman, is named for K.P.H. Meanwhile, nearby Eliza Brook was given its name by Harrington's friend John Stetson in honor of K.P.H.'s wife, whose middle name was Eliza.

During his tenure with the AMC, Harrington personally selected the sites for several new backcountry shelters that were built by the club, and he oversaw the replacement of the original Liberty Spring Shelter, which he himself had erected years earlier.

For a good number of years, Harrington also edited several chapters of the AMC's popular *White Mountain Guide*, and in 1926, he had published his delightful book, *Walks and Climbs in the White Mountains*. This book, published by Yale University Press, remains one of this writer's favorite White Mountain titles, not only for Harrington's engaging text but also for its many interesting photographs, taken at a time when lumberjacks were still plying

White Mountains Hiking History

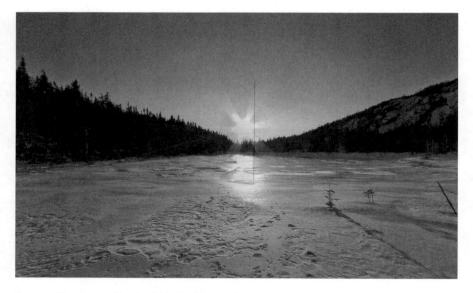

Remote Harrington Pond, which lies just southeast of the peak of South Kinsman, is named for longtime NWIA member Karl Harrington. *Photo by Chris Whiton.*

their trade in the forests of the Pemi Valley and disastrous fires had scarred many of the mountain slopes.

Harrington lived a good long life, finally passing away in 1953 at the age of ninety-two. Although he may be long gone from this world, his love for the mountain country lives on in the many hiking paths he helped construct more than eighty years ago, as well as in his extensive writings, which include his autobiography, *Walks and Climbs*, and his frequent contributions to *Appalachia*, journal of the AMC.

Pathfinders to North Woodstock and Vicinity

In 1898, just a year after the North Woodstock Improvement Association was founded, the first guidebook devoted solely to the upper Pemigewasset River Valley appeared in print.

The Franconia Notch and Pemigewasset Valley was penned by Frank O. Carpenter, who, as mentioned earlier, was a prominent trail enthusiast with a particular fascination with the western slopes of Mount Lafayette and

Frank Carpenter's guidebook, *Franconia Notch and the Pemigewasset Valley*, was published in 1898 and provided detailed information on local trails and others points of interest. *Author's collection.*

Franconia Ridge. Carpenter's 136-page guide, like so many guides of that period, was as much a tourist guide as a tramper's guide. Sure, it included information on the region's various natural landmarks of interest and how to reach them, but it also contained lots of information on local hotels and businesses, as well as brief descriptions of some of the summer cottages occupied each year by NWIA members such as Carpenter, Karl Harrington and Colonel Horace Fisher. For the record, Carpenter's summer home on the lower slopes of Parker Mountain just south of the village was known as Ferncliff, Harrington's as Quisesana and Fisher's as Kiameche Cottage.

Carpenter's guide is probably most noteworthy for the many places of interest it lists that, in all likelihood, are unknown to most of today's Pemi Valley visitors and probably a majority of North Woodstock's year-round residents, too. It has been years since anyone has directed hikers to "Sweetheart Rocks" and "Lucky Stone Beach" along the Pemi near the former Fairview Bridge. The same goes for "Elisha's Rock," described by Carpenter as a curious flat ledge covered with strange figures and markings that a former owner, Elisha Smith, "used to trace the representation of the most important events of Biblical history."

A few other examples include the "Ice Caves," which were a set of long, narrow caves three miles or so south of North Woodstock, accessible from Sylvester Sawyer's Fern Hill Farm. (Of the caves, Carpenter added, "The caves are the haunts of hedgehogs, and are wet and dirty; not worth visiting, except from the farms near by.") Also, Adam's Spring, situated two miles north of North Woodstock, was a few rods beyond Harvard Brook. "A thirsty traveller should take a cup of this cold, white water," advised Carpenter.

In 1905, seven years after Carpenter's guide first appeared, the NWIA put together the first guide of its own when it published the first edition of *A Little Pathfinder*. As the club noted on the introductory page, "This little pathfinder must be considered not a substitute for, but merely introductory to, a more complete guide to the region, such as that prepared by Mr. F.O. Carpenter."

Little Pathfinder was nowhere near as thorough as Carpenter's guide, being merely a small booklet describing the existing walking paths in the North Woodstock area. Four editions of the path book were published between 1905 and 1921, with none probably running more than sixteen pages in length.

The NWIA path book included brief descriptions of most of the major landmarks in the upper Pemi Valley, such as the high peaks of Franconia Ridge, nearby Mount Moosilauke, Moran (or Lonesome) Lake and Mount

The North Woodstock Improvement Association's *A Little Pathfinder* was published in at least four editions. This one is from 1914. *Author's collection.*

Pemigewasset (Indian Head.). Lesser-known destinations, however, also abounded: Hubbard Gorge near Mirror Lake in Woodstock; Barron Mountain, a wooded knob on the east side of the valley opposite Woodstock village where "limited views were gained from a series of ledges"; Mill Brook Cascades, along Mill Brook in West Thornton; and the Mount Cilley settlement, the abandoned farming community on which Woodstock first developed nearly two centuries ago.

Here are a few more samplings of what was found in the *A Little Pathfinder*:

- *CANNON (OR PROFILE) MOUNTAIN: The bold, rocky ridge on the left of the Notch. Interesting views of the Franconia Range and of the Pemigewasset valley. A good, though toilsome, path enters the woods behind the Profile House, and is well marked to the summit.*
- *MOUNT FLUME: A serrated summit, mostly wooded, but offering a view similar, though inferior, to that from Mt. Liberty. The roughest, but most interesting ascent is by way of the [1883] slide. Follow "Flume" brook to its base (or use log road leading from Johnson's), and climb slide, preferably on [left] side. A blazed trail for top of ridge leaves [left] side of slide near the top.*
- *FRANCONIA FALLS: Here the Franconia Branch (one of the important streams forming the East Branch of the Pemigewasset) descends rapidly over large bare granite ledges amid picturesque surroundings. On account of its remoteness it has been seldom visited except by lumbermen and sportsmen.*

- *LOON POND MOUNTAIN: A height due east of North Woodstock and convenient for ascent. View includes Mt. Washington and various other peaks.* [Loon Pond] *is visible from a ledge a little east of the usual view point. The path leaves the railroad track at a point about 50 rods south of the railroad bridge, and is clearly marked to the summit.*
- *THORNTON GORE (AND WATERVILLE): A beautiful valley with adjacent hills, formerly well tilled in prosperous farms, now nearly all abandoned. Roads are still passable on each side of the valley for several miles beyond the center of the former settlement, with broad prospects. The lumber railroad from Woodstock follows* [north] *side of valley beyond East Pond path and nearly to height of land in Waterville Notch, whence path and roads leads down…to Elliot's hotel.*

The History of Lost River and Kinsman Notch

Kinsman Notch, which is situated along Route 112 between North Woodstock and Easton, is one of more than twenty so-called notches, or mountain passes, in the White Mountains. Though it is not as well known as some of its sister notches, such as nearby Franconia Notch or Crawford and Pinkham Notches well to the east, the elevation at its height of land is a respectable 1,870 feet above sea level, or about 1,000 feet higher than the neighboring villages of North Woodstock and Lincoln (811 feet). The pass is flanked to the north by the long-running Kinsman Ridge and to the south by Mounts Blue and Jim, as well as the massive Mount Moosilauke.

While it is almost a certainty that Native Americans and early settlers of the region visited Kinsman Notch on occasion, it wasn't until 1810 that the first trail or path was established up to it. The so-called Spencer Trail was a crude route up and over the pass, but it did allow for easier movement of the mail between North Woodstock, the Bungay/Wildwood section of Easton and the Haverhill area along the Connecticut River. When a much better road was constructed through Franconia Notch a few years later, use of the Spencer Trail dwindled, and it eventually became overgrown and presumably tough to follow.

Kinsman Notch and the ridge of mountains running north from the height-of-land in the notch are named for Nathan "Asa" Kinsman, an Ipswich, Massachusetts native, born in 1741, who settled with his family in the region in the late 1700s. Kinsman was a veteran of the French and Indian War and the American Revolution, and during the former, he was

The Lost River Valley as it appears today from the top of the Dilly Trail, high above Lost River Gorge. *Photo by Author.*

captured by the French and presumably ransomed back to the colonists. Kinsman was married twice, his first wife and two infant children dying premature deaths.

In 1782, Kinsman moved to the Lincoln area from Concord, settling on a four-hundred-acre tract of land on the west slopes of today's Mount Kinsman in what was then known as Lincoln Gore. This tract lay on the other side of the mountains from Lincoln (or Morristown, as it was known then) proper and would eventually be annexed. As a result, Kinsman is considered the first permanent settler of what we now know as the town of Easton.

With the aid of two men, it's believed that Kinsman cut a nine-mile trail over the mountain range that now bears his name to the site of his future homestead. There, he built a log cabin and raised his family with his second wife, Elizabeth Shattuck of Littleton, Massachusetts. Some histories speculate that his route through the woods might have actually come from the Haverhill area and through Benton, not through Lincoln, but the story most often related states that Kinsman's route over the mountains took

him over the height-of-land where a power line now intersects Kinsman Ridge, just above Bog Pond. This mountain pass, in fact, was for many years known as Kinsman Notch, while today's Kinsman Notch was referred to as Moosilauke Notch. Somewhere down through the years, the name of Kinsman Notch was transferred from its original remote location to the more accessible pass near Beaver Meadow.

It's thought that the Kinsmans had four children (Stephen, Nathan Jr., Peter and Martha) at the time of their relocation to Lincoln, while a fifth child (Timothy) was born shortly thereafter in 1783, probably the first child born in present-day Easton. A sixth child, also named Peter, was born in 1775 but died a year later.

Kinsman was a well-respected man, described both as a "hatter" and a physician. In 1790, he was appointed coroner of Grafton County, which at that time also included most of today's Coos County. He was also active in local politics. He lived to the age of eighty-one, dying on February 8, 1822, and is buried at the Kinsman Cemetery in Easton, in the shadow of the peaks of the Kinsman Range.

Discovery of Lost River

Over the years, the discovery of the Kinsman Notch region's most famous natural landmark—Lost River Gorge—has been credited to a pair of Woodstock men who in 1852 headed up the Moosilauke Brook valley on a fishing trip. Following the course of the stream that runs east from the height-of-land in the notch, brothers Lyman and Royal Jackman were carefully making their way along the boulder-strewn stream bed when Lyman suddenly disappeared from sight, having slipped on a moss-covered rock and into a hole. After a fall of about fifteen feet, he found himself floundering in a waist-deep underground pool. His brother came to his rescue, fishing him out of the pool that would eventually become known as "Shadow Cave."

Royal Charles Jackman (1828–1915) was for many years a Woodstock resident, although he was not a native of the town, being born in the New Hampshire town of Canterbury. He has been described as a carpenter, blacksmith and carriage repairman. His younger brother, Lyman Jackman (1837–1913), was born in Woodstock (or Peeling) on August 15, 1837, and is best known as a decorated Civil War soldier serving in the Sixth New Hampshire Regiment

for the Union army. Captain Jackman, who was wounded at the Second Battle of Bull Run (August 1862) and later taken prisoner by the Confederates (September 1864), also authored the official regimental history of the Sixth New Hampshire Regiment. The Jackman brothers came from a large family, which included ten other siblings. Lyman was the youngest of the family's four boys born to Royal and Lucretia Jackman.

While word of the Jackman boys' discovery slowly passed from one settler to another, undoubtedly prompting return trips by the Jackmans and occasional treks to the gorge by other curiosity seekers, it wasn't until September 1874 that the first thorough exploration of Lost River took place. This multi-day excursion, organized by Isaac Fox, proprietor of the House of the Seven Gables in North Woodstock, included seven people, three of them women. The group spent two full days exploring in the Lost River caves, and subsequent accounts of their trip appearing in newspapers in several prominent city papers in the Northeast brought Lost River its first widespread notoriety.

In 1893, Royal C. Jackman, who'd returned to the North Woodstock area after an absence of fifteen years or more, guided a group of tourists up into the gorge, and upon reaching the spot where his brother had fallen into the cave forty-one years earlier, he remarked, "This is where my brother found the lost river." Thus was born the name of this great wonder of the White Mountains.

The next big year in Lost River history was 1895, when two separate excursions into the gorge opened the way for future explorers to enjoy its unique scenery. In early August, W.S.C. Russell of the Cascade House in North Woodstock and Charles Jackman, son of Royal Jackman, ventured to the gorge, where they "cut paths, and spotted trees so that ladies may go there with little trouble," wrote Russell in the Bethlehem-based summer newspaper, the *White Mountain Echo and Tourist's Register*. They also explored nearby Beaver Brook and its falls—"unquestionably the grandest falls in New England; which probably less than a score of people have seen," wrote Russell, adding also that "a good path has been cut to them…and has been extended over the mountain to join the old Moosilauke road to Woodstock."

Also in August 1895, Frank Carpenter, another summer resident of North Woodstock and a lover of the mountains, trekked up to Lost River with Elmer Woodbury, a lifelong Woodstock resident and faithful promoter of the region. It was during this trip that Carpenter named the various caves in and around Lost River. He later returned to the gorge and painted the names on the rocks near each cave.

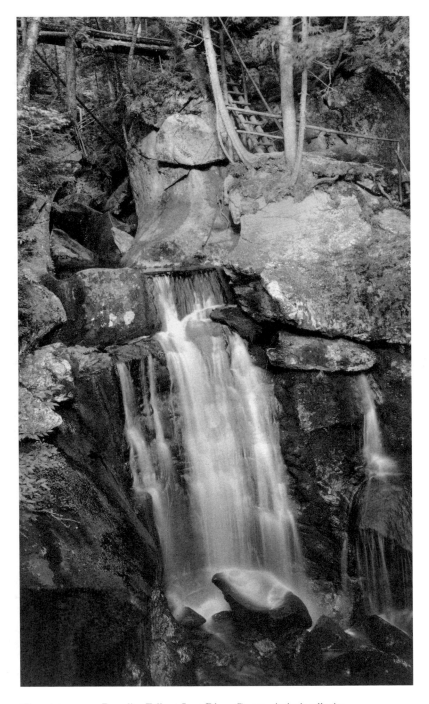

The picturesque Paradise Falls at Lost River Gorge. *Author's collection.*

Carpenter, who once described the Lost River Gorge as a "remarkable freak in brook scenery," was a founding member of the trails-oriented North Woodstock Improvement Society, and in his 1898 guidebook *The Franconia Notch and Pemigewasset Valley*, he espoused the glorious virtues of the Lost River boulders caves, claiming, "Nowhere in the White Mountains except in King's Ravine and the Ice Gulch in Randolph are there such mighty boulders and ledges as in the Lost River, and the latter surpasses the others in the number and extent of the shadowy caves." He went on to warn of its inherent dangers, however, writing, "It is very difficult for women to visit, as it is often dangerous, is far distant in the forest and requires severe exertion… It is very dangerous for any one to visit the gorge alone, and unwise for the inexperienced persons to attempt it without a guide, as there are many chances for serious or fatal falls into deep caverns." His guidebook then proceeded to list the five most "experienced" guides to the Lost River caves. These included Royal Jackman, Elmer Woodbury, Wilbur Hunt of North Woodstock, W.S.C. Russell and Carpenter himself.

Woodbury (1865–1940), meanwhile, was an active and devoted public servant, serving his community at one time or another as selectmen, school board member, auditor, tax collector, forest fire warden, state road agent and town representative to the New Hampshire General Court. As mentioned previously, he was also a great supporter of his town, and writing under the name of "Justus Conrad," he was able to promote the Woodstock region through published pieces appearing in the July 1897 issue of *Granite Monthly* and in a booklet titled *The Town of Woodstock and Its Scenic Beauties*. Writing under his own name, he also penned the illustrated booklet *Historical Narrative of Lost River and Kinsman Notch*, which is the basis for much that we know of the early history of Lost River and Kinsman Notch.

ERA OF LOGGING IN KINSMAN NOTCH

With Lost River's fame spreading following its inclusion in several local guidebooks, including Carpenter's, local officials deemed that it was finally time for a permanent road to be established up into Kinsman Notch and beyond. In 1901, the towns of Woodstock and Easton laid out a road seven miles in length that linked Woodstock to the Wildwood area of Easton. Two years later, in 1903, the state appropriated additional money to make

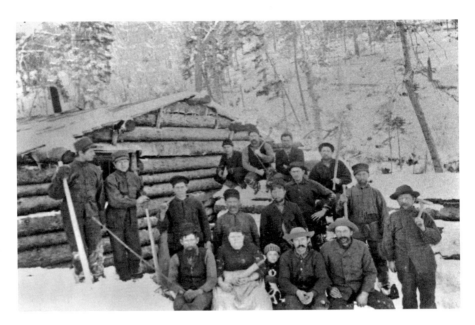

A crew of lumbermen from Camp 5 poses for a group shot outside a Lost River Valley logging camp. *From* Logging Railroads Along the Pemigewasset River *(2006).*

improvements to the road, but further improvements came to a halt in about 1905 when timber companies invaded the forested slopes of nearby Mount Moosilauke and the valley of Lost River. Their presence would be felt for years to come as they practically swept clean all the softwood trees that were accessible to the lumberjacks' axes.

Publishers Paper Company began its invasion of the region in 1906 when it began harvesting timber in the Agassiz Basin area, four miles below Lost River. Other local timber interests (including George L. Johnson of Monroe) operated in the basin from 1903 to 1914, establishing logging railroad lines to aid in shipping cut timber to mills in Lincoln and Woodstock.

Heavy timber cutting was also taking place at this time on the north and west side of Kinsman Notch, in nearby Tunnel Brook valley and in the valley of the Wild Ammonoosuc River. Here, logs were "driven" down the river from the top of notch to the Connecticut River by way of the Wild Ammonoosuc and Ammonoosuc Rivers. A series of four dams constructed between Kinsman Notch and Bath served to control the flow of the river, making log driving possible on this otherwise poor driving river. Much of this timber was cut by crews working for the Fall Mountain Paper Company, which later became International Paper Company.

This locomotive, the H.B. Stebbins, worked the rails of the Gordon Pond Railroad during its relatively short existence in the early 1900s. *From* Logging Railroads Along the Pemigewasset River *(2006)*.

In the book *Walks and Climbs in the White Mountains* by Karl Harrington, the author described a visit to the Lost River area during the height of the logging activity thusly: "On arrival at the point in the road where we must leave for the gorge, we found ourselves in the midst of a wilderness of devastation, dead treetops, felled logs, and a network of abandoned log roads. Our cup of indignation was full when irresponsible parties built a 'shack' wherein to exploit the traveller's hunger, thirst, ignorance, or other weaknesses."

The intensive logging of this region of the White Mountains reached into many different corners of the Lost River Valley and its surroundings. The Gordon Pond Railroad extended from Johnson village in North Lincoln toward local landmarks such as Gordon Pond and Elbow Pond and well up the Lost River Valley, practically to the lower entrance to the gorge itself. Cutting occurred also on the nearby slopes of Mounts Blue and Jim, Mount Cushman and Mount Cilley.

C. Francis Belcher, in his book *Logging Railroads of the White Mountains*, quoted a *Collier's* magazine article (May 1, 1909) by writer Ernest Russell in which he reported, "Between 600 and 700 men are at work [in the Lost River area]...butchering the beautiful forest of that valley and doing the most reckless lumbering I have ever seen in the mountains. Do not lay this blame at (lumber baron James E.) Henry's door but at the door of the great paper company (Publishers) that sold the stumpage of that 30,000 acre tract to a worse than ignorant contractor."

With a relatively short time frame in which to harvest as much timber as possible, George Johnson's timber crew went all out in their efforts, averaging more than 14 million board feet per year during their ten-year contract. In one year alone, under the direction of legendary woods boss James E. ("Jakey") McGraw, some 26 million board feet of timber were cut.

As has been related by several noted logging historians, including Dartmouth's J. Wilcox Brown and Vermonter Bill Gove, McGraw infamously devised a way to harvest a patch of prime virgin spruce that was situated above a tall, rugged cliff high above Beaver Pond and Kinsman Notch on the slopes of Mount Blue; this was a place most considered unreachable by man or beast. The resourceful McGraw cut a logging road around the cliff and up into the steep valley of Stark Falls Brook and then devised an ingenious scheme for sliding the logs down to the meadow below.

At various times, the Lost River–Kinsman Notch logging operations included several mills along the lower Lost River, several logging camps (including one along Lost River and another in the Beaver Meadows), various railroad lines extending a total of 13.5 miles from Lincoln and even a small schoolhouse near the sawmill settlement.

By 1908, there was a growing interest in preserving the Lost River area, as officials with the Society for the Protection of New Hampshire Forests began to negotiate and raise money to purchase about 150 acres near the gorge. By 1912, the society's efforts to save Lost River came to pass when a 148-acre tract was purchased for $7,000 from area timber interests. A good portion of this total ($5,000) came from the estate of Miss Dora Martin of Dover, who willed to the society money earmarked specifically for the purchase of forestlands within the state. Her bequest, coupled with $1,315 raised from White Mountain area hotels and other money donated to the society from members and friends, added up to the $7,000 needed to buy the land from timber baron George Johnson, who owned cutting rights to the trees still standing on the Lost River tract. This purchase was the first and oldest of the society's many New Hampshire properties.

According to forest historian J. Wilcox Brown, George Johnson later regretted his decision to sell the Lost River tract as he never envisioned the land as having potential as a recreational hot spot. During a visit to the gorge in 1916, where they spent the day watching throngs of visitors pay twenty-five cents admission to the caverns, Johnson famously told reservation superintendent Michael McCarthy, "Dammit, I never should have sold this place, and I couldn't see it."

White Mountains Hiking History

The Birth of Hiking in Kinsman Notch

Soon after the Lost River property was in the hands of the Forest Society, Edward Rollins, brother of former New Hampshire governor (1899–1901) Frank W. Rollins, stepped forward and contributed a sizable amount of cash toward the construction of a shelter, restaurant and gift shop for visitors to Lost River. This building, with its massive stone fireplace, is still in use today as the gift shop. Additional funds to improve access to the gorge itself and to allow for the construction of stairs and boardwalks were raised by various women's clubs throughout the Granite State.

By 1915, with automobile use on the rise across the country, a new road suitable for cars was constructed through Kinsman Notch, making Lost River that much more accessible to the general public. That year, some eight thousand visitors toured Lost River, and the Forest Society also decided that it was time to raise additional funds to purchase another 160 acres at the notch, including the Beaver Meadow at the height-of-land.

After a banner year at Lost River in 1916 (sixteen thousand visitors), the Forest Society went ahead and purchased the Kinsman Notch tract from International Paper Company in 1917. It also announced plans to restore a six-acre lake originally made by beavers. Just a year earlier, the U.S. Forest Service (USFS) had purchased some three thousand acres of land on the eastern slopes of Moosilauke and Kinsman Ridge. It would be another fifteen years, however, before the U.S. Forest Service would acquire the timberland in the Wild Ammonoosuc valley to the west of the notch.

The years 1916 and 1917 also marked the birth of the "hiking age" in the Lost River area. First the Dartmouth Outing Club (DOC), led by Leland "Doc" Griggs, a Dartmouth professor and longtime faculty booster of DOC, constructed a new footpath up the steep northeast slope of Mount Moosilauke. Starting at Beaver Meadow, this path followed several old logging roads and pretty much followed the course of scenic Beaver Brook. The lower section of the trail appears to have replaced a previously "orphaned trail" that apparently went as far as Beaver Falls—probably the remnants of the path opened in 1895 by Russell and Jackman. Nearer the summit ridge, the new Beaver Brook Trail pretty much followed the route of the former Little's Path from North Woodstock.

In 1917, during the summer and fall months, the Appalachian Mountain Club began work on a new path that would link Kinsman Notch with its neighboring mountain pass to the north, Franconia Notch. Karl Harrington,

the devoted trail builder and summer resident of North Woodstock, is credited with much of the work on this trail, which would eventually run all the way to the summit of Cannon Mountain. The last link of the new Kinsman Ridge Trail—running from Lost River to the summit of South Kinsman—was more or less completed in 1919. The following year, the same stretch was brought up to regular trail standards by AMC trail crew members, among whom was included future governor Sherman Adams, then a Dartmouth College undergraduate. Previously, this section of the trail was primarily a blazed route. (The original route of the Kinsman Ridge Trail did not stay strictly on the ridgeline, thus the summit of Mount Wolf was bypassed. AMC trail crews rerouted the path over Mount Wolf seventeen years later in 1937.) Today, both the Beaver Brook Trail up Moosilauke and the Kinsman Ridge Trail up Mount Wolf are links in the Georgia-to-Maine Appalachian Trail.

In the early 1930s (perhaps 1932), an overnight shelter for hikers was erected at the base of the Beaver Brook Trail by the Dartmouth Outing Club. The shelter was actually built in 1932 on the Dartmouth College campus in Hanover as an attraction for the school's annual Winter Carnival. It was soon thereafter dismantled and reassembled at the Kinsman Notch site. Since the forest service at the time prohibited the use of any "local" timber for constructing such a structure, this allowed the DOC to get the shelter built without breaking any USFS regulations. A new shelter replaced the original Beaver Brook shelter in 1957. This shelter was dismantled in 1993, and a replacement structure was built farther up the Beaver Brook trail on the slopes of Moosilauke.

In the 1960s and 1970s, Kinsman Notch was the starting point for ambitious Dartmouth College students taking part in the so-called Trailwalks, which required participants to hike nonstop from the notch to Hanover—a total of fifty-five miles. These walks would typically begin late on a Friday afternoon, and hikers would reach the Dartmouth campus sometime the following afternoon. In early October 1969, George Cain (class of 1970) and Frank Bickford (class of 1972) set a new "direct route record of 20 hours and 30 minutes," the direct route being over Holt's Ledge near Lyme and Orford.

It was also during this same time frame that the Forest Society cut a new hiking trail linking the Lost River property to the Kinsman Ridge Trail at a point 0.6 mile up from Route 112 at the height-of-land. The rough-and-tumble Dilly Trail leaves from the Lost River parking lot and climbs steeply for a little less than half a mile to a ledge outlook 750 feet above the Lost River complex. The path then continues on easier grades to the Kinsman Ridge Trail.

White Mountains Hiking History

The Civilian Conservation Corps

While much of the history of the Kinsman Notch area revolves around Lost River Gorge, the Appalachian Trail and the logging era of the late eighteenth and early nineteenth centuries, another fascinating part of its story is the Depression-era Civilian Conservation Corps (CCC), which established two camps within a few miles of the notch itself.

From 1933 to 1937, and again for two years beginning in April 1939, the CCC's Wildwood Camp operated just west of Kinsman Notch in the Wildwood section of Easton. The camp, located off Tunnel Brook Road, initially opened in April 1933 but was not fully staffed until early May, when enrollees from the 139th Company at Fort Devens, Massachusetts, were transferred to Wildwood. This being the first camp of its kind in New Hampshire, it was not all smooth going for the CCC boys, at least not at the start.

"The trials and tribulations of the Pioneer construction company in its task of building the first CCC barracks in New England are chronicled less formally in the memories of those enrollees who piled lumber and drove nails for the future home of the 101st Co.," noted the *Pioneer*, the camp newspaper. "It has been remarked that all the mistakes of barracks construction were made in the Wildwood buildings, but what gigantic enterprise has not been

One of the main projects undertaken by Civilian Conservation Corps members based at the Wildwood Camp was construction of the new Warren-Woodstock Road, which was completed in the fall of 1936. *Author's collection.*

introduced with at least a few mistakes. That these faults have been readily recognized and properly corrected is evidence by the practical yet attractive barracks which identify the subcamp sites."

Massachusetts "boys" formed the vast majority of the original company, while a mix of boys from Massachusetts and Maine composed the company in its later years. Initially, the camp offered little in the way of entertainment for the enrollees, at least at night after work hours. "There was no radio…not even a deck of cards so that the men…had nothing to do in the evenings but smoke their pipes and cigarets [*sic*] and talk…The men would have read but they had no books, magazines, nor newspapers to look over," reported the *Manchester Union Leader*. As a result of this story about the Wildwood camp, a fund drive was established, and before too long, donations flooded into the camp. Donated items included radios and radio equipment, jigsaw puzzles, horseshoes, volleyballs, cards and plenty of reading material. A Manchester organizer of the donor campaign also used money raised in the drive to purchase basic baseball equipment, which he and a party of other Manchester residents personally delivered to the remote camp. No sooner had the boys finished their meal that they "unpacked the bats, gloves and a couple of baseballs and were out in a nearby field playing," reported the paper.

One of the primary projects undertaken by this CCC camp was construction of the so-called Woodstock-Warren Road (today's Route 118) to the east of Kinsman Notch. Work on this rugged mountain road was completed in the fall of 1936. The Wildwood camp's second go-around (1939–41) was prompted by the great New England Hurricane of September 21, 1938, which devastated much of the forestland in the White Mountains west of Mount Washington and the Presidential Range. According to the June 1939 edition of *Appalachia*, Lost River and Kinsman Notch were hit hard by the storm. "We find that the young growth in the district around Kinsman Notch and Lost River was not hurt badly, but on the Notch itself, below Beaver Lake, and continuing north for a mile on both sides of the highway, everything is flat," reported the journal. For two years after the big blow, the Wildwood CCC crew spent most of its time cleaning up the timber that had been blown over during the hurricane.

North Woodstock was also home to two other CCC camps, one off Tripoli Road (east of present-day I-93) and the other closer to Kinsman Notch between Jackman Brook and present-day Route 118. The latter was situated about half a mile south of Route 112. This camp opened in June 1935 as a National Forest facility but was not fully staffed by a full complement of enrollees until 1937, when it was then under the jurisdiction

of the state forestry department. In February 1936, several men from the Wildwood Camp were transferred to the North Woodstock camp so that work on the Woodstock-Warren Road could continue through the winter months. Several months later, in May 1936, the entire 101st Company was transferred there. Besides working on the Woodstock-Warren Road, the "boys" undertook several other area projects that summer, including construction of Lincoln's telephone lines, building a road entrance to the camp, construction of the Wildwood Forest Camping Ground and building the Elbow Pond road bridge. This camp closed in April 1939.

Other CCC projects handled by the two Kinsman Notch–area camps over the course of their existence included work on the North and South Road connecting Benton and Glencliff and further improvements to Tunnel Brook Road, construction of a dam at 117-acre Long Pond in Benton, improvements to the Benton Trail up Mount Moosilauke and the Tunnel Brook Trail at the western base of Moosilauke and construction of the Coppermine Ski Trail on Cannon Mountain and Coppermine shelter near Bridal Veil Falls.

Charles E. Lowe, Legendary Guide

Of the many colorful characters in White Mountain annals, few compare with Charles E. Lowe, a longtime Randolph, New Hampshire resident who helped build several of the early trails on the Northern Peaks of the Presidential Range. These include, of course, his namesake trail, Lowe's Path, the first constructed up Mount Adams, the second-highest peak in New Hampshire.

Charles Edward Lowe was born on Deer Isle, Maine, near Mount Desert Island, to Clovis Lowe and Alpha Green Lowe on June 20, 1838. His grandfather, Levi Lowe, was a Cape Cod native who served in the Revolutionary War. Clovis and Levi Lowe first visited Randolph in the early 1800s while driving a herd of cattle from the Maine coast to Canada. They resettled there in 1818 but, over the years, also lived in nearby Jefferson and Berlin, as well as along the Maine coast. Levi Lowe was the town of Randolph's first town clerk. He died in 1836 at sixty-four years of age. Clovis Lowe was also active in local affairs, serving as the town's postmaster for many years, as selectman and as a state legislator.

Charles Lowe was educated in the schools of Frankfurt and Portland, Maine, then moved to Randolph at the age of nineteen. At first, he rented a farm, but later he and his father purchased twenty acres of land on which they settled. Charles Lowe was also a Civil War veteran, enlisting in 1864 in Company I, First New Hampshire Artillery, which was assigned to the Sixth Army Corps and stationed at Arlington Heights, Virginia. Lowe's unit was still there at the time of President Abraham Lincoln's assassination in

April 1865. It has been written that Lowe and his father were both staunch Republicans, and during the 1860 election that saw Lincoln elected to the presidency, the two Lowes were reportedly the only residents in Randolph who cast ballots for him.

Upon his discharge from the Union army in 1865, the twenty-six-year-old Lowe returned to Randolph and "carried on for several years the business of dealing in gum, buying and selling an average of three tons per year," recalled the *Mountaineer* newspaper of Gorham in its March 20, 1907 obituary on Lowe. He also owned and operated a lumber mill on Israel River and later purchased a second mill from G.W. and N.W. Libby. After that mill burned in the late 1860s, he "adopted the profession of guide."

His namesake trail up 5,774-foot Mount Adams, still in existence today, was built in 1875–76 by Lowe and fellow trail-builder and longtime Randolph summer resident William Gray Nowell. The path ascends the peak via so-named Nowell Ridge. At the time it was built, it was considered one of the best paths in the region, and users were charged a toll up until 1880. In its first season of use, it saw more than three hundred trampers follow its course. Later, Lowe's Path was the first to be adopted by the fledgling Appalachian Mountain Club, which was organized in January 1876. Historians Guy and Laura Waterman call the cutting of Lowe's Path the birth of the "modern era of trail building."

Lowe was instrumental in the building of several other Northern Peaks trails

In 1876, Charles Lowe helped construct the first footpath into wild, rugged King Ravine. *Photo by Guy Shorey, courtesy David Govatski.*

as well. In 1879, he spotted the Cabin-Cascades Trail between Nowell Ridge and Cascade Ravine (which would become one of AMC's earliest paths in the Whites). Other trails to his credit include the original Cook Path to Ice Gulch in the nearby Crescent Range, and the rugged King Ravine Trail (1876) on the northern slope of Mount Adams. In 1877, again under Nowell's guidance, Lowe established the first path from the Glen House in Pinkham Notch to Carter Notch via Nineteen-Mile Brook and, a few years later, helped on construction of the Carter-Moriah Trail. Lowe even traveled further afield in his trail-making efforts, for in 1878 he cut a new trail up Mount Willey in Crawford Notch.

Along with Nowell, Lowe is also credited with building a temporary bark shelter beside Lowe's Path and the Cabin-Cascades Trail. This crude structure, maintained by AMC for more than a decade, was later replaced by Nowell's enclosed Log Cabin in 1888–89.

Lowe's knowledge of the woods and nearby mountain terrain, along with his likable personality, made him one of the most popular guides of his day. In his early guidebooks to the White Mountains, author Moses F. Sweetser referred to Lowe as "the best guide to the northern peaks, and is said to be cautious, intelligent, and companionable." At the time, he charged three dollars per day for his guiding services. "All lovers of nature find in Mr. Lowe a congenial spirit, and his acquaintance among visitors to the White Mountains was wide," noted the *Mountaineer*.

In early May 1907, at a meeting of the AMC in Boston, the recently deceased Lowe was recognized by President Charles Fay, J. Rayner Edmands and William Nowell, who wrote, "Trained as a land surveyor in a timbered region, [Lowe] was a 'pathfinder' before our modern ways were opened. Endowed with a rare love of the mountains and a spirit as strong as his vigorous body, he bore a leading part in the laying out and construction of the earlier paths to the northward of Mt. Washington and on the Carter Range. Possessed of a genial temperament and an appreciative and companionable nature, he seemed never happier then when acting as a trusted guide to those whom, similar tastes had attracted to the grand heights."

A number of Lowe's guided tours in the mountains are, fortunately, featured in a fascinating collection of letters and diary entries published in the book *Mountain Summers* (Gulfside Press, 1995). In one diary entry from September 6, 1883, one of the region's best-known woman climbers of the late nineteenth century, Isabella Stone, described in detail a Lowe-led ascent of Mount Adams.

Nineteenth-century guide and trail-builder Charles Lowe of Randolph is pictured with his wife, Mahala, in this glass slide image from the 1890s. *Randolph Mountain Club/Lowe Archive.*

"Our path is excellent, but very steep, and the small trees left growing on either side are of great assistance in pulling oneself up," wrote Stone of their ascent via Lowe's Path. Later, she added, "Following the cairns, we clamber over rocks of all sizes lying at every conceivable angle. Mr. Lowe seats me in a sheltered nook to admire the northern view. Up again and on we go hand in hand over rocks. I get out of breath very quickly and have to stop very often to ret. The wind is very cold and blows hard, giving me, with the exertion, a terrible pain in my head, which is relieved by sitting down, or even standing still in sheltered spots."

Lowe, Stone and the guide's "yellow dog," Rover, eventually did reach Adams's summit, just four hours after departing from the mountain's base. There, despite a temperature of just forty-four degrees and a chilling breeze, the trampers stay a full two hours at the top, enjoying a prepared lunch and "admiring the view and identifying various peaks."

As evidenced elsewhere in *Mountain Summers*, Lowe's duties as guide were not without peril. In an entry from the previous year (1882), Marian Pychowska wrote of an incident in which Lowe "by a misstep so slight he can hardly account for the result, he broke something in his leg, whether a small bone or tendon he could not tell. This occurred near the top of [Mount] Madison and the poor man had to limp all the way down here. Of course, there is no more guiding for him this year."

On February 17, 1887, Charles Lowe made the first successful winter ascent of Mount Adams, three years after a previous attempt at the summit had failed due to poor weather conditions above the tree line. Little is known or has been written about his solo climb of the peak, though the Watermans and the *Mountaineer* newspaper noted that he was carrying "a strong staff with a pick, which he could stab into the ice."

Lowe was twice married. His first wife, Mahala, died in June 1894, leaving behind her husband and seven children, including Vyron, Charles and Thaddeus, all mentioned as guides in Lowe's newspaper obituary. Just two years later, he wed a second time, marrying a widow from Lunenburg, Vermont, Lorena Cheney Abbott.

Lowe moved from Randolph to Randolph Hill in the mid-1890s when he took over ownership and management of the Mount Crescent House (formerly known as the Randolph Hill House). He ran this popular summer establishment until his death on March 16, 1907.

The Goodriches of Waterville Valley

It probably goes without saying that the most famous father-son tandem in White Mountains annals is that of Abel Crawford and Ethan Allen Crawford, pioneer settlers and innkeepers whose names live on in the famous mountain pass to which they were so closely associated. The Crawfords, who at various times owned inns and taverns from one end of Crawford Notch to the other, played a huge role in the development of the early tourist trade in the region, not only providing places for travelers to stay but also developing some of the first walking trails and bridle paths up Mount Washington and the southern reaches of Presidential Range.

Over the years, plenty has been written about the Crawfords, but not nearly as much has been written about another father-son duo who also had longtime ties to the Whites but whose legacy pales in comparison to that of the Crawfords, even though these two men did far more for today's hikers than Abel and Ethan Crawford.

Arthur L. Goodrich and Nathaniel Lewis Goodrich never lived in the White Mountains, per se, but for many summers were closely associated with the Waterville Valley area. Arthur, the father, began summering in the valley in the mid- to late 1870s and over the course of the following thirty to forty years was an instrumental figure in the development of the fine trail system that pretty much exists intact today in Waterville, more than a century later.

Arthur's son, Nathaniel, whose ties to the valley go back to his days as an infant, closely followed his footsteps, at least in terms of his dedication to trail-building in the Whites. Nathaniel, along with fellow Appalachian

Mountain Club members Charles Blood and Paul Jenks, is considered the "father" of the modern-day White Mountain trail system, for the three of them working together as a team pieced together over a period of two decades the interconnected trail network that has long been enjoyed by area trampers.

Not a lot has been written about Arthur L. Goodrich, so his private life away from the Whites remains something of a mystery, at least to this writer. As mentioned earlier, we do know that his visits to the Waterville Valley area began sometime in the late 1870s and that his interest in mountain climbing and exploring existed then as he was part of a contingent of volunteers, some of them AMC members, who helped construct the first footpaths up Mount Tecumseh and Sandwich Mountain (or Sandwich Dome) back in the summer of 1879. Goodrich himself is listed in *Appalachia* as an AMC member in the May 1882 edition of the club's journal, and within a decade, he was serving as the club's councillor of exploration (a post that by then was on its way to being phased out since most of the White Mountains region had been extensively explored by club members by the mid-1890s).

In addition to working on the first Sandwich Mountain and Mount Tecumseh paths, Arthur Goodrich is credited with building several other paths in the valley. As a member of the newly organized Waterville Athletic and Improvement Association—formed in 1888, in part, to improve trails in and around the valley—Goodrich put through the Scar Trail, probably in the late 1880s, and the Kettles Path (1890). Then, in perhaps his most ambitious Waterville Valley project, he cut the long-abandoned Ravine Path up Mount Osceola in 1900, which climbed the steep headwall of the ravine in the col (or lowest spot) between the main and east summits of the well-known local landmark.

His rambles around the valley also led to one interesting discovery: the huge boulder on the east slope of Osceola ever since known as Goodrich Rock. The boulder, which measures about sixty by fifty by fifty, is one of the largest glacial erratics in New Hampshire and is appropriately named for its discoverer.

In 1892, Goodrich penned an article about the valley in *Appalachia*, noting that at that point in time, the Waterville trail system exceeded thirty miles. The article included a sketch map of the area and its trails, an item Goodrich felt was much needed at the time. "The details of the topography of this region are almost wholly unknown and are absurdly wrong, at least in many particulars, as figured on our best maps," wrote Goodrich. "If the recent sketch map will add a little towards final accuracy, the maker is content; and

This large glacial erratic on the lower slope of East Osceola is named Goodrich Rock after its discoverer, Arthur Goodrich. *Photo by Steven D. Smith.*

if this description of the place brings other good Appalachians to the valley, so much the better for those already there."

That same year (1892), A.L. Goodrich also published the first edition of his popular and useful little guidebook to the area, *The Waterville Valley: A History, Description and Guide*. Later updated editions appeared in 1904 and 1916.

NATHANIEL LEWIS GOODRICH: TRAIL BUILDER EXTRAORDINAIRE

If Arthur L. Goodrich is considered one of the most instrumental early trail-builders of the Waterville Valley area, then his son has to be considered one of the founding fathers of our modern-day White Mountain trail system.

Along with fellow AMC members Charles Blood and Paul Jenks, Nathaniel Lewis Goodrich oversaw the development of a trail system that connected previously constructed local trail networks. This expansion occurred over a two-decade period starting in the early 1900s and included the building of such important footpaths as the Garfield Ridge Trail, the Webster Cliff Trail, the Kinsman Ridge Trail and the Twin Range Trail (or Twinway, as it is known today). Over a fifteen-year period, this work resulted in more than 170 miles being added to AMC's White Mountain trail system.

Nathaniel Goodrich summered practically all his life in Waterville Valley, first coming to the valley as an infant. Upon Goodrich's death in 1957, his pal Blood wrote about his early acquaintanceship with Goodrich: "I first met Nat Goodrich in July 1897, riding on the stage into Waterville. I was an absolute greenhorn in the mountains, while to me he even then seemed a seasoned veteran, for he had spent his summers there since babyhood. For the next twenty years our summer vacations brought us together almost every year, and from him I learned much of my woodcraft."

Goodrich graduated from Amherst College in 1901, then went on to receive a library science degree at the State Library School in Albany, New York. After working in the New York State Library for several years, he moved on to library positions at the University of West Virginia, the University of Texas and, finally Dartmouth College in Hanover, where he remained the rest of his working days. During World War I, noted Blood, Goodrich put

his innate skill of reading and evaluating maps to good use as he served as a captain of Military Intelligence with the general staff in Washington, D.C.

Goodrich was also a fine skier and mountaineer in his day, taking trips at various times to the Canadian Rockies and to the high peaks of Europe. Over the years, he penned several ski- and climbing-related stories for *Appalachia*, among them "A Ski Holiday in the Alps" (December 1929) and "A Look at the Pyrenees" (June 1933). Among his mountaineering claims to fame, he was a member of the four-person team that made the first ascent of 10,270-foot Mount Olive, a peak along the Continental Divide in the Canadian Rockies. He was also a member of the first team to ice-climb Central Gully in Mount Washington's Huntington Ravine back in February 1927.

In addition to his trail- and mountain-related activities in the Whites and elsewhere, Goodrich was also a fine writer and historian. His book *The Waterville Valley*, published in 1952 by the North Country Press of Lunenburg, Vermont, is one of the most interesting and readable town histories of any White Mountain community.

As a longtime AMC member, Goodrich served at various times as councillor of trails and on the Guidebook Committee, the club's Nomenclature Committee, the Committee on Trails and the Committee on Hut, Trail and Camp Extensions.

In the June 1918 edition of *Appalachia*, there appears an article by Goodrich entitled "The Attractions and Rewards of Trail Making," which was a paper he'd read the previous December at the annual meeting of the New England Trail Conference. Goodrich waxes almost poetic about the task of first envisioning, then actually cutting a new path: "Like many greater things, a trail begins at a chance remark. Looking at distant ridges through the haze of the noon-halt pipe—or dreaming over the map in idle winter moments—the word slips out: 'There ought to be a trail on that ridge.' Months, or years, later one who heard, and scoffed, summons his friends to help make that trail, his trail, the trail he is surprised no one ever thought of making before."

He added, "Of trail making there are three stages. There is dreaming the trail, there is prospecting the trail, there is making the trail. Of the first one can say nothing—dreams are fragile, intangible. Prospecting the trail—there lies perhaps the greatest of the joys of trail work. It has a suggestion of the thrill of exploration. No one of us but loves still to play explorer. And here there is just a bit of the real thing to keep the play going."

WHITE MOUNTAINS HIKING HISTORY

In 1923, at the conclusion of his three-year term as AMC councillor of trails, Goodrich wrote of his enduring relationship with Blood and Jenks:

> *You doubtless suppose that during the past nine years the Club has had three Councillors of Trails. It is a delusion. There has been but one. Whether Mr. Blood, Mr. Jenks, or myself held that title mattered nothing. We were all on the job, all the nine years. We found the Club spending $500 a year on trails and leave it spending $3000. We added three shelters and rebuilt one. We cleared, mostly with our own hands, fifty-five miles of new trail. Our loot consists of memories of many happy days on the trails, and a few old signs. It was a sort of Triumvirate. Sometimes we called it a dynasty. Dynasties are supposed to be unqualifiedly evil. We consider ourselves an exception.*

Among Goodrich's other contributions to *Appalachia* was an article in the December 1930 edition titled "Old Peppersass." In this piece, Goodrich described the scene on Mount Washington a year and a half earlier when Old Peppersass, the famed first engine of the Cog Railway, met its demise in a tragic run up the mountain on July 21, 1929. Goodrich was on the mountain that same day, having taken an earlier train to the summit. On his train's descent, it came across the accident scene; one man had been killed and another seriously injured. He chose to hike down off the mountain once it was evident that his train would not be able to continue its journey down to the base station. He was evidently one of the first persons off the mountain that day who'd actually witnessed the accident scene.

One final legacy of Nathaniel Goodrich is the tradition of "peakbagging" in the White Mountains. In the December 1931 edition of *Appalachia*, it was Goodrich who introduced AMC members to this now time-honored pursuit when he compiled and published a list of thirty-six White Mountain peaks with an elevation of four thousand feet or greater. Noting that elsewhere abroad and in the United States, climbers have been aspiring to climb peaks of a certain elevation level for a number of years, "It occurred to me it might be amusing to try this game on the White Mountains," wrote Goodrich. "It seemed a harmless folly. The motive behind it is not on a plane of high spiritual detachment perhaps—but what would you? It appears to drive men up mountains they would otherwise neglect. To accept 4000 feet as the base level for New Hampshire climbers seems reasonable. Very many of our peaks of

their height have individuality and views; very many below it have neither. But there are not a few humps and shoulders, some with familiar names, which hardly seem to rate as separate mountains. A line must be drawn, and quite arbitrarily I put it at 300 feet."

Goodrich noted that his 300-foot rule eliminated some peaks—such as Clay, Willey, Guyot, North Carter and Lincoln—but not all that many. That rule was later scrapped in favor of the so-called 200-foot rule, which means that there must be at least a 200-foot rise from the low point on any connecting ridge to the actual summit. By modifying Goodrich's arbitrary 300-foot rule, peaks such as Mounts Willey and Lincoln were added to the list. The present-day list of peaks includes forty-eight summits, from 6,288-foot Mount Washington to 4,004-foot Mount Tecumseh.

Compendium of Trail Guides and Builders

Charles Winthrop Blood (1878–1966), an Auburndale (Newton), Massachusetts native, joined the Appalachian Mountain Club in 1912 and was one of the "old masters" of trail building, teaming with fellow club members Paul Jenks and Nathaniel Goodrich on some of the most ambitious projects in White Mountain annals.

Like Jenks and Goodrich, Blood was a longtime summer resident of the Waterville Valley area, and it was there that he learned the "secret of good tramping and the art of trail cutting." Later in life, after spending a few years at a boardinghouse in Whitefield, he relocated his summer base to the Ravine House in Randolph, where he continued his trail-building activities.

Beginning in 1913 and continuing for the next twenty-five years, Blood played an important role in laying out and opening some eighteen trails, including the Webster Cliff, Garfield Ridge, Ammonoosuc Ravine, Kinsman Ridge, Mahoosuc, Twinway and Nancy Pond Trails. Ironically, Blood once wrote that during his early years of visiting the Waterville region, he rarely left the regular well-kept trails. "As a matter of fact," admitted Blood, "I had a peculiar dread of being alone in the forest. It was purely psychological." He also wrote that he had "only a vague sense of topography" and that the thought of locating and opening a new trail "never occurred to me."

Upon assuming the role of AMC councillor of improvements in 1914, Blood said that he had two basic objectives in mind. One was to maintain the club's existing network of trails in the Whites; the other was to extend and expand the trail system. True to his word, Blood oversaw the construction

of three important new trails during his three-year term, with the rugged Webster Cliff Trail taking shape in 1914, the Ammonosuc Ravine Trail to Lakes of the Clouds being cut the following year and construction of the Garfield Ridge Trail being undertaken in 1916.

With Jenks taking over the role of councillor of improvements in 1917, Blood continued to take part in what he dubbed their annual "trail sprees." The result in ensuing summers included the completion of the Kinsman Ridge and Wildcat Ridge Trails, the opening of the Mahoosuc Range Trail and the building of a connecting trail linking AMC's Zealand Falls Hut with the Twin Mountain range.

During his long affiliation with AMC, Blood served the club in many capacities. Besides his three years as councillor of improvements, he also served as councillor of topography, vice-president, president, trustee of special funds and treasurer. He was also a valued member of the club's guidebook committee, working on seventeen different editions of the venerable *AMC White Mountain Guide*.

FRANK O. CARPENTER was part of the trail-building community that evolved in the North Woodstock area in the 1890s. The schoolteacher from English High School in Boston had a special affinity for nearby Franconia Notch, and in particular the western slopes of Franconia Ridge. Besides exploring all the existing trails on the ridge, constructing new paths and rehabilitating old ones, Carpenter authored a guidebook to the Franconia Notch region in 1898. He was also a charter member of the North Woodstock Improvement Association, a band of outdoor enthusiasts that hoped to "render more accessible" the various points of interest found up and down the Pemigewasset Valley. For a more detailed look at Carpenter and his accomplishments, see the "Legacy of the North Woodstock Improvement Association" chapter.

FRANKLIN P. CLARK hailed from North Woodstock and helped with trail-building activities in the Franconia Notch region in the 1890s; he was also a well-known guide. Frank Carpenter once referred to him as the "only thoroughly trained guide to the Franconia Mountains."

Clark helped with the building of a new approach trail to Mount Garfield from Gale River Bridge in 1897, just in time for that year's AMC Field Meeting at the Profile House in Franconia Notch. The previous year, in late 1896, Clark had also worked on the Lafayette-Liberty Ridge, extending an existing path from Little Haystack to the top of Mount Liberty.

At AMC's thirty-fourth Field Meeting at the Deer Park Hotel in North Woodstock in July 1899, he and Carpenter led a tour through Lost River Gorge. Then, in September 1900, during AMC's first Walking Trip—featuring a week's worth of walking over hill and dale from Hebron to Lisbon—Clark served as guide on a venture that saw fourteen participants cover an estimated 120 miles in seven days. Their walking excursion included visits to Sandwich Dome, Mount Osceola and the Franconias.

In his 1898 guide to the Franconia Notch region, Carpenter was effusive in his praise for Clark, writing, "The only experienced guide to the Franconia Mountains and the surrounding forests is Mr. Franklin P. Clark of North Woodstock, whose expert woodcraft, great strength and thorough knowledge of the peaks and forests combine to make a most trusty and reliable guide and pleasant companion on a mountain climb or fishing trip. His terms are two to three dollars per day. He is the guide employed by the Appalachian Mountain Club whenever one is needed in the Franconia region or to cut new paths."

EUGENE BEAUHARNAIS COOK (1830–1915) was a tireless explorer, trail-builder and hiker who is credited with building more trails in the late nineteenth century than anyone else in the Whites. He was a New York City native whose family moved across the Hudson River to Hoboken, New Jersey, when he was a child, and it was there that he would live the rest of his life.

Cook was educated at Princeton University and became an authority on several abstruse topics, including chess, for which he was known worldwide. His collection of chess books, now housed at Princeton, was believed at the time to be the third largest in the world. Cook was also a superb violinist, and according to Randolph, New Hampshire historian George Cross, "the rooms of his Hoboken home were filled with collections of rare objects, the walls adorned with busts and portraits of great musicians and composers." A talented figure skater, he has also been dubbed by some the "father of figure skating in America," while his witty character and ceaseless sense of humor were well-known characteristics.

Cook's connection with the White Mountains dated back to 1872, when he first summered in the region at the Philbrick Farm in Shelburne. In subsequent years, he summered in the Sugar Hill area, then came to Randolph and the Ravine House in 1878, which became his permanent summer residence.

As an early member of the Appalachian Mountain Club, Cook explored all over the Whites, often thrashing his way up pathless mountainsides

Eugene Cook, one of the most ambitious White Mountain explorers of the late 1800s, is pictured here at the Randolph Mountain Club's annual summer picnic in 1913. *Randolph Mountain Club/Peek Archive.*

in the company of his sisters, Lucia Duncan Cook Pychowska and Edith Walker Cook, and his niece, Martha Marian Pychowska. His most frequent mountain companion, however, was William Peek, who is profiled later in this chapter.

Among Cook's most ambitious treks was his September 27, 1882 Presidential Range traverse, the first ever undertaken. Accompanied by fellow Randolphian Dr. George Sargent, the pair left the Ravine House at 5:00 a.m., climbed Mount Madison and then proceeded south across the Range as far as Mount Clinton. After reaching the Crawford House, where they dined, they headed back to Randolph on foot, following the main highway to Bretton Woods and the White Mountain House, then taking the Cherry Mountain Road to Jefferson and the main road from Jefferson Meadows to Randolph. They arrived back at the Ravine House at 1:24 a.m. on the twenty-eighth, some twenty hours and twenty-one minutes after their start the previous morning.

The paths that Cook built during his time in the White Mountains usually took more direct routes up the slopes, at least in comparison to those constructed by J.R. Edmands, who was well known for his graded, hiker-friendly paths. In *Forest and Crag*, Guy and Laura Waterman wrote that Cook and Edmands frequently engaged in friendly debate over the merits of their respective methods of path-making. Cook was of the school that the quickest way to the summit was straight up the mountainside. Edmands tried to make things easier for trampers.

For one three-year term, E.B. Cook served as councillor of exploration/ trails for AMC. During this time (1883–85), he oversaw development of many new trails and spent much time tramping through previously unexplored regions of the Whites. In the December 1883 edition of *Appalachia*, for instance, there are numerous trip reports either written by Cook himself or including him as one of the participating members. These adventures found him climbing Mount Hale in the Little River Range, the North Country peak of Mount Pliny, Mounts Caribou and Royce in the Evans Notch region, Mounts Langdon and Parker near Bartlett, Mount Nancy in Crawford Notch and Mount Haystack (Garfield) in Franconia.

THOMAS CULHANE (1830–1903) was one of the "original" mountain guides, who for years was affiliated with John M. Thompson and the Glen House at Pinkham Notch and John R. Hitchcock of the Alpine House in Gorham and Tip-Top House on Mount Washington.

White Mountains Hiking History

Culhane was a native of Rossie, New York, where he grew up and worked in lead mines. He eventually made his way to Shelburne, New Hampshire, where he worked in the lead mines there. He later took up farming in Martin's Location, and during the summer months, he worked for the hotels as a mountain guide. Culhane's parents, John and Jane Culhane, were from southern Ireland and immigrated to the United States in 1825. At least two of his siblings—an older brother, Patrick (born on September 29, 1824) and a younger brother, John (born on September 15, 1844)—also settled in the Gorham area, working at the Shelburne Lead Mine, the Glen House (for John Hitchcock) and later for the Grand Trunk Railway. Patrick Culhane also farmed at Martin's Location, a short distance below the Glen House.

Among Thomas Culhane's claims to fame was that he was among the men who bore Lizzie Bourne down off Mount Washington after her fatal climb of September 13, 1855.

In an obituary appearing in the *Mountaineer* newspaper of Gorham shortly after his death, the paper lamented, "Another link connecting the present generation with the early days of summer travel on this side of the mountains…has been destroyed by the death of Thomas Culhane. As far as we know the only one of the 'old guard' left is Benjamin F. Osgood, now at the Crawford House. There are, of course, others younger, who came upon the scene before the older ones got out of harness, but of the older ones, with the exception noted, Thomas Culhane was the last."

Louis Cutter is best known for his early maps of the Presidential Range, the first of which he drew in 1885. For decades, his maps were featured in the *AMC White Mountain Guide*. *Randolph Mountain Club/Cutter Archive.*

Louis Fairweather Cutter (1864–1945) was once described as an "enthusiastic tramper." He was a longtime member of both the Appalachian Mountain Club and the Randolph Mountain Club (of which he was a founding member), but he is best known for his mapmaking skills and his

early topographic maps of the Presidential Range and other regions of the White Mountains.

Born in Cambridge, Massachusetts, he was introduced to the late nineteenth-century hotbed of New Hampshire hiking, the Randolph Valley, during a family visit to the Ravine House in 1885. He took an instant interest in the Northern Peaks, especially wild and rugged King Ravine, and quickly began participating in the trail blazing efforts of Randolph's most famous path-makers. During that summer in Randolph, Cutter produced his first map of the mountains in conjunction with an engineering studies project. This map would become the prototype for the many maps he would create and revise from then until his death in 1945.

Cutter joined AMC in 1889, and among the number of club posts he held at one time or another were councillor of topography and chairman of the Committee on Nomenclature. It's his detailed maps of the Whites that are his enduring club legacy, however, as they appeared in every edition of the *AMC White Mountain Guide* from 1907 to 1998.

JOHN RAYNER EDMANDS (1850–1910) was born in Massachusetts and was long affiliated with the Harvard Observatory in Cambridge and the Appalachian Mountain Club. He left his mark on the White Mountains with his remarkably smooth, graded trails that traversed some of the roughest terrain in New England.

An MIT graduate (class of 1869) at just nineteen years of age, Edmands was an aspiring engineer who eventually landed an assistantship at Harvard Observatory in the early 1880s. Louis Cutter, the late nineteenth- and early twentieth-century mapmaker, wrote in 1921 that Edmands first visited the White Mountains in 1868, where he summered in the Jefferson Highlands region. It was during that summer that Edmands first ventured into what would become one of his favorite White Mountains haunts, Cascade Ravine, on the lower slopes of Mount Adams in the Northern Presidentials. Edmands was also a founding member of the Appalachian Mountain Club, and in the course of his thirty-four years of affiliation with AMC, he held just about every important post within the club, including serving as president in 1886.

"In all these early years, the need of better paths must have been very evident to Mr. Edmands," wrote Cutter in August 1921, "but he does not appear to have been active in making them." His commitments to the Harvard Observatory apparently prevented Edmands from spending extensive stretches of time in the White Mountains. But once his duties with the observatory lessened, he was able to finally spend his entire summers

in the Whites, first at Jefferson, then at Randolph and later in the Bretton Woods/Crawford Notch area. During these summer stays, Edmands took it upon himself to redesign and build new footpaths that the public could use and enjoy without too great an effort.

According to Cutter, Edmands was greatly influenced in his path-building methods by two visits he made to the Rocky Mountains, in 1888 and 1890. "The gradual mountain trails made by miners...were a revelation to him, and he saw at once that similar paths could be made here," wrote Cutter. Another influence was his wife, Helen, who died in 1888 shortly after giving birth to a daughter. "His wife, to whom he was deeply devoted, died young, but not before she had experienced the difficulties of climbing in those White Mountains of which her husband was so fond," recalled colleague Arthur Stanley Pease in his book, *Sequestered Vales of Life*. "After her death, in part as a tribute to her memory, he spent his long summer seasons and very

Construction of Cascade Camp in Cascade Ravine was supervised by J.R. Edmands in 1902. It was one of three remote camps built in the Northern Presidentials under Edmands's supervision. *Mount Washington Observatory/Shorey Collection.*

considerable amounts of money in the construction of easier trails to open up the more interesting parts of the Presidential Range to persons unequal to very rough and vigorous exertion."

In July 1891, Edmands, local guide Charles Lowe, his son Charley and S.H. Thorndike ventured into the wild and beautiful ravine that Edmands had visited as a teenager and constructed a crude camp (Cliff Shelter), blazed a trail up the so-called Emerald Ridge (which Edmands renamed Israel Ridge) and possibly picked out the site for his soon-to-be-built Cascade Camp. The following year (1892), construction was undertaken on Cascade Camp, which was designed by Edmands and built by Hubbard Hunt and others (including Charley Lowe and Thorndike). The camp was finished by mid-June, with Edmands, Hunt and others spending their first night in the camp on June 13. During this visit to Cascade Camp, Edmands, Hunt and Lowe also started working on building "the Perch," a birch-bark shelter at the head of Cascade Ravine (midway between the Randolph Path and Israel Ridge Path).

Edmands's original base camp for his White Mountains trail work was the Mount Adams House at Jefferson Highlands. At about the same time that he began developing his cabins in and around Cascade Ravine, he moved to Randolph and the Ravine House, long the haven of path builders and AMC members.

In 1892 and 1893, Edmands continued to make improvements on the Israel Ridge Path—including the erection of cairns on its above tree line sections. This was also when he put in his "Pleasure Paths" for use by visitors to his camps. Among his next projects was the designing and building of "the Link," which gave him a direct path from the Ravine House to Cascade Camp. It was laid out in 1893 and probably built over a period of a few summers. It was eventually extended from Cascade Camp over Israel Ridge and then into Castle Ravine and up to the first Castle on Castellated Ridge. From there, it ran all the way around to the west slopes of Mount Jefferson, where it met the Caps Ridge Trail from Jefferson Notch. Also during this time, Edmands was busy laying out the Gulfside Trail from Bowman to Mount Washington.

Edmands's next big project was construction of the graded Randolph Path, which ran from the railroad depot in Randolph westward across the various ridges, valleys and ravines of the Northern Peaks to the Gulfside Trail at what would become known as Edmands Col at the top of Israel Ridge. This historic route, designed to make for an easier walk from Randolph to Mount Washington, passed by or near William Nowell's

Log Cabin (1890) and Edmands's own Perch, always at a gradual, comfortable grade.

There was a method and sound reasoning for Edmands's ambitious path-building on the Northern Peaks, at least according to Cutter. He wrote that through his rapid development of camps and paths, Edmands hoped "that so great an interest in, and love for the forests could be aroused, that means could be found for purchasing and preserving the most beautiful parts before the forest should be made into lumber and pulp."

When it became inevitable, however, that the Northern Peaks' slopes would soon be laid to waste by lumbering interests—despite a growing outcry from the public to preserve these forests—Edmands had no choice but to end his work in this region of the Whites and shift his operational base to the western slopes of the Presidentials, where he settled at Bretton Woods and began developing trails for hotel interests there, including John Anderson of the Mount Pleasant House. His major trail-building accomplishments here including the reopening of the former Fabyan Bridle Path up Mount Pleasant and the eventual rebuilding of the upper section of the trail across the face of the summit dome to the col north of Mount Pleasant, where it intersected the Crawford Path near Red Pond. It was from here that Edmands also undertook the task of constructing the graded Westside Trail linking the Crawford Path with his Gulfside Trail along the western base of Mount Washington's summit cone.

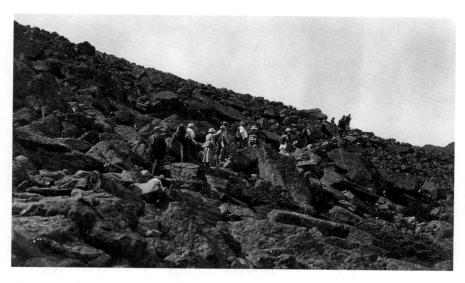

The easy grades of the Gulfside Trail, another project of J.R. Edmands's, make for easy walking for this group of turn-of-the-century trampers. *David Govatski.*

While lumbering activity took its toll on the paths of the Northern Peaks for much of the first decade of the twentieth century, Edmands's well-regarded paths were spared the damage of others, due mainly to his ongoing dialogue with officials from the Berlin Mill Company, with whom he pleaded his case that the lumbermen do everything in their power to preserve his paths intact. Of his paths on the Northern Peaks, only the Link sustained monumental damage.

Edmands fully expected to return to Randolph to restore his paths once lumbering had ceased. But his premature death in 1910 prevented that from happening. It's a bit ironic that he died just as lumbering activity in this region was finally ramping down.

Edmands's paths are notable for their lack of steep grades and their grading. Unlike other early path-makers in the region (such as E.B. Cook), Edmands refused to stick to the normal standards of the day, avoiding as much as possible the banks of streams and the often precipitous ridgelines that were usually used in laying out the most direct routes for paths. He preferred smoother, easier grades, on which trampers would find the going less tiring both in ascent and descent, and made careful studies of the grades when laying out his paths. He frequently found it best to cut a trial path, which would be abandoned if a better way could be found.

No one built graded paths like J.R. Edmands. His almost sidewalk-like trail up Mount Pleasant (or Eisenhower) is a testament to his trail engineering skills. *Photo by Guy Shorey, courtesy David Govastki.*

There was also a distinct method for his "cairning" paths above the tree line. He would construct two large cairns ten feet apart, indicating the direction of the path, followed in another fifty feet by two more cairns. Even under the most adverse conditions, which frequently included heavy fog at these heights, Edmands hoped that trampers would be able to follow the trail of cairns. At turns in the trail, three cairns were built—one at the angle, the others about ten feet from the angle, indicating the directions of the trail.

A sometimes demanding superintendent while on the job, Edmands was apparently not the easiest man to work for. "He supervised and took an active part himself, being most particular about every detail and so insistent that his exact directions be carried out that some rather independent axemen at times became restive," wrote Pease. "To the skill of the trained engineer he added the imaginative eye of the artists, so that his trails became and have long remained, with their beautiful vistas through forest, objects of surpassing beauty as well as of substantial convenience."

JONATHAN RAY EVANS (1878–1957) was a Gorham native who for many years ran the family-owned Willis House. He was an active mountain climber and hiker and an AMC member and helped to blaze many mountain paths in the region.

Evans was born to Quimby and Frances (Willis) Evans on September 26, 1878. He was educated in his hometown and lived there his entire life. He was married on November 29, 1909, to Grace Platts of Reading, Massachusetts. She predeceased him in 1954.

On March 30, 1926, Evans accompanied Arthur Walden, dog tram driver, to the top of Mount Washington in his historic ascent of New England's highest peak. Walden's famed dog, Chinook, led the team of Alaska huskies up the mountain, accompanied by Evans, Joe Dodge and several members of the press. After his mother's death (date unknown), Evans took over management of the Willis House on Main Street in Gorham. He and his wife ran the hotel until his retirement in 1945.

ARTHUR LEWIS GOODRICH and NATHANIEL LEWIS GOODRICH were the father-son team who contributed as much to the White Mountain trail system as any such tandem in New Hampshire annals. While the elder Goodrich, Arthur, helped develop the trail system in the Waterville Valley region in the latter stages of the nineteenth century, Nathaniel Goodrich, along with Charles Blood and Paul Jenks, is considered one of the "fathers" of the modern day White Mountain trail system, for it was this trio of devoted trailblazers that

collectively pieced together over a period of two decades the interconnected trail network that has long been utilized by area trampers. For a detailed look at the lives and accomplishments of Arthur and Nathaniel Goodrich, see the "Goodriches of Waterville Valley" chapter.

JAMES GORDON, a native of Canada but a longtime resident of Randolph, was also part Indian. He was described as being tall and "straight as an arrow," with jet-black hair and eyes. "No one looking at him could be in doubt of his being part Indian." Though a carpenter by trade, he spent much of his time fishing, hunting and guiding tourists about the mountains.

Among his most famous clients was Reverend Thomas Starr King, whom Gordon took to many places around the region, including wild King Ravine. It was supposedly Gordon and King who cut the first hiking path up Mount Hayes in Gorham. He was also very active locally, serving at various times as town clerk and selectmen. In his seminal tribute to the mountains, *The White Hills: Their Legend, Landscape and Poetry*, published in 1859, Starr King wrote that his guide "is as much at home in the woods as a bear, and…gets along without a compass in their thickets by having the instincts of a bee."

KARL POMEROY HARRINGTON (1861–1953), although a native of New Hampshire's seacoast region, was nonetheless a mountain man through and through, spending his summers in the North Woodstock area, where he took to the woods to hike the mountains, fish the streams and build many miles of new trails.

Harrington was one of the founding members of the North Woodstock Improvement Association (NWIA), which was devoted to building and maintaining paths in the upper Pemigewasset River Valley.

A longtime professor at Wesleyan University and a native of Great Falls (Somersworth), New Hampshire, Harrington spent his summer months at his red-roofed chalet known as Quiseana, high up on the north-facing slope of Parker Ledge just south of North Woodstock village.

Along with fellow NWIA members, Harrington helped lay out and maintain the club's many paths in the vicinity of North Woodstock. For a more detailed look at Harrington, see the "Legacy of the North Woodstock Improvement Association" chapter.

WARREN HART (1872–1943), a Milton, New Hampshire native and Boston University Law School graduate (1899), was a member of the Appalachian Mountain Club's first guidebook committee and during his one three-year

White Mountains Hiking History

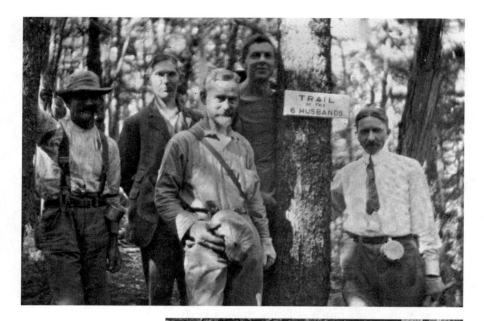

Above: Warren Hart (center) supervises construction of the Six Husbands Trail in 1909. *Appalachian Mountain Club.*

Right: Hikers ascend ladders on the wildly steep Six Husbands Trail in the Great Gulf. This trail, cut in 1909, was one of many cut in the region during Warren Hart's thee-year reign as AMC councillor of trails. *Mount Washington Observatory/Shorey Collection.*

Trailblazers of the Granite State

Left: The cutting of new trails in the Great Gulf presented hikers with some interesting challenges, such as the ascent of so-called Jefferson's Knee. *Photo by Guy Shorey, courtesy Randolph Mountain Club.*

Below: Looking down into the Great Gulf in 1910, during the heyday of Warren Hart's great trailing-making spree. *Appalachian Mountain Club.*

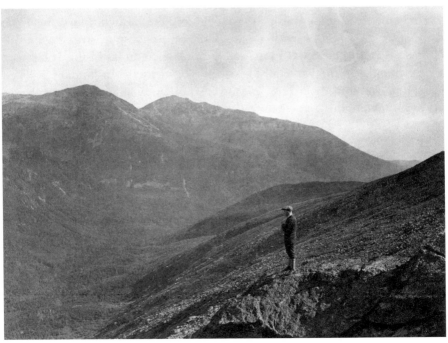

term as AMC councillor of trails, opened up the club's new network of trails in the rugged Great Gulf region and along the Presidentials. Paths he helped open during this intense period of trail construction included Star Lake, Great Gulf, Chandler Brook, Six Husbands, Adams Slide and Alpine Garden. It was also under his leadership that the historic, but long lost, Davis Path from the lower end of Crawford Notch to Mount Washington was "ferreted out" and reopened in 1910.

"Physically, he was robust and vigorous," wrote fellow AMC member Charles W. Blood. "He was definitely an individualist. He was not interested in following the beaten track. He preferred to take tramps in regions unfrequented by most people." This was evidenced by Hart's fascination with New Hampshire's less visited North Country. Blood said that for many years, Hart was responsible for the North Country section of the AMC guide, "a section about which no one else on the Committee knew much of anything."

HUBBARD H. HUNT (1834–1903) was an early mountain guide from Randolph. He was described thusly in *Randolph: Old and New*: "With a slender, well-knit figure, curling black hair and beard, dark blue eyes that in moments of excitement looked black…Mr. Hunt was a man to enjoy as well as trust on a long tramp."

He came to Randolph from Whitefield and established a farm near the Bowman farm. Besides serving as a guide, he was also a very active trailbuilder, assisting the AMC in its trail maintenance duties in the 1880s and 1890s, mainly on the western side of the Presidentials. In January 1884, it was Hunt and innkeeper Laban Watson who jointly led a winter excursion up Mount Madison, an account of which appeared in the April 1884 issue of *Appalachia*.

PAUL ROCKWELL JENKS (1872–1953) graduated with honors from Dartmouth College in 1894 and then went on to a long career in education, serving first as principal and teacher in Plymouth, New Hampshire, and then as a teacher in Brooklyn and Flushing, New York. He was an ambitious explorer and a grand trailmaster, playing a huge role in the development of a unified trail system in the Whites during the 1910s and 1920s. He's best known as being a member of the so-called Waterville Valley triumvirate that did so much to advance the trails system of the region. His frequent trail partners were Charles W. Blood and Nathaniel L. Goodrich, all summer residents of Waterville. In 1912, Jenks purchased

a summer home in Whitefield, not far from the luxurious Mountain View House, where he spent the rest of his summers.

Jenks's long friendship with Blood began in 1903 when Blood first came to Waterville. That year, they did some hiking together, and Blood said that he learned "the lesson I have never forgotten," that being "that for the ordinary man the secret of good tramping is to keep the pace slow enough so that he has no desire to stop and rest."

In the summer of 1907, Jenks and Blood tackled their first trail-building project, cutting a new shortcut from Waterville Valley to Mount Whiteface, which connected with the existing Woodbury Trail. "Judged by the present AMC standards, it was a most amateurish job of clearing—but the trail was well located and saved more than half a mile in distance," recalled Blood in 1953.

Jenks was the driving force behind the construction of the Webster Cliff Trail between Mount Pierce and Crawford Notch. In 1912, Jenks alone cut a trail between Mounts Webster and Jackson and was already contemplating extending that path over Webster and down to the Willey House Station at the south end of the notch. In 1913, Jenks coaxed Blood to join him atop Mount Jackson with the idea that the two of them would go forward with the cutting of a path from Jackson to Pierce, which they accomplished. Then, in 1914 Jenks, Blood, Nat Goodrich and George Blaney returned to the southern Presidentials in early August and extended the path south from Mount Webster and along the Webster Cliffs to the Crawford Notch Highway near Willey House Station. The completion of this trail, combined with later work that decade on the Garfield Ridge Trail, went a long way toward linking the eastern and western peaks of the Whites via one continuous path.

Blood admitted that during his three-year term as AMC councillor of trails (1914–16), Jenks was his "right-hand man," for "without him and Nat Goodrich I should have had little to show for my three years in office." Blood went on to say:

> *When Paul succeeded me as Councillor in 1917, our present trail system began to take shape, pushing south over the Kinsman Range and north into the Mahoosucs, relinquishing certain trails to the Forest Service and exchanging others with the Randolph Mountain Club…He developed a system under which each trail would be standardized at the end of a predetermined number of years. He systematized the tools needed for trail work and the tool best adapted to each type of work. He began a*

comprehensive study of trail signs—the most durable type of board to use and the best paint to use.

His interests were wide and varied—from song birds to railroad timetables, from grand opera to professional baseball. But the mountains were his greatest love.

Jenks spent many days out in the field with the early AMC work crews, inspiring them with his enthusiasm and his knowledge of how best to construct a proper mountain footpath. According to Blood, up until AMC named a trailmaster in 1926, Jenks was primarily the club member in charge of the trail workers, making out their weekly schedule, paying the bills and handling all associated paper work.

Jenks was also well known for taking on the task of making many of the AMC trail signs. As noted by Councillor of Trails Fred Barrows in his annual report for 1928, "It is impossible to state in a few words the importance and value of this phase of trail work. It is a task that cannot, like our general trail work, be accomplished entirely in the summer months, but occupies not a little of the time of Mr. Jenks during the long winter months, when he so painstakingly prepares and paints a great number of signs in order that no time will be lost in placing them when he is free to go on with his field work the following summer."

CHARLES EDWARD LOWE (1838–1907) was one of best-known mountain guides of the late nineteenth century. A longtime Randolph resident, he helped build several of the early trails on the Northern Peaks. Lowe's Path, the first trail up Mount Adams, was built by Lowe and fellow trail-builder William Gray Nowell in 1875–76. The path ascended the peak via Nowell Ridge. It was considered one of the best paths in the region at that time, and users were charged a toll up until 1880. In its first season of use it saw more than three hundred trampers follow its course.

Lowe's brother, Thaddeus Lowe, was the well-known Civil War–era balloonist and inventor of the funicular railroad that ran up Mount Lowe in the Sierra Madre Range of California. His mother, Alpha, was a lineal descendant of Peregrine White, who was born on the *Mayflower* as it lay in Cape Cod Harbor in November 1620. For a more detailed look at Lowe, see the "Charles E. Lowe, Legendary Guide" chapter.

CHARLES "CHARLEY" LOWE, THADDEUS LOWE and VYRON LOWE were all sons of Charles Lowe (see previous entry). They each followed in the

footsteps of their father and served as mountain guides and trail-builders. Vyron Lowe was town treasurer in Randolph for many years starting in 1904. Charley Lowe was a guide and took over management of the Mount Crescent House upon his father's death in March 1907. He helped build the original birch-bark shelter at the Perch at the head of Castle Ravine, working with fellow guide Hubbard Hunt and J. Rayner Edmands. Thaddeus Lowe worked on the extension of the Carter-Moriah trail with William Nowell, Hubbard Hunt and others in August 1885.

Mountain guide Vyron Lowe, son of Charles Lowe, stands in front of the Perch, probably in 1902. *Randolph Mountain Club/Lowe Archive.*

DR. WILLIAM GRAY NOWELL (1837–1929) was the first councillor of improvements for AMC, the builder of the Log Cabin alongside Lowe's Path and a trail enthusiast and builder. He received his collegiate training at Bowdoin College. He later studied theology and was ordained to the ministry, preaching in Portsmouth, New Hampshire, in 1872. He was also a physician, preferring teaching to practicing medicine. He taught in schools in Malden, Massachusetts, and New York City.

Nowell began summering in Randolph in 1873, first at the community's various hotels, then at his Log Cabin on Nowell Ridge. This enclosed cabin was built in 1890, replacing the former "AMC Camp" built on the site in 1876. It was the first permanent camp built on the northern slopes of the Presidentials. Nowell frequented the cabin for more than two decades and then conveyed the rights to Thaddeus H. Lowe, who in turn conveyed them to the Randolph Mountain Club. This structure was razed in 1985 and replaced with a sturdy open-door cabin built in memory of John Boothman Jr., woodsman and former owner of the Mount Crescent House.

William Nowell is seen here at his Log Cabin on the upper slopes of Mount Adams. The cabin was the first permanent camp to be built on the Northern Peaks. *Photo by Guy Shorey, courtesy Randolph Mountain Club.*

George Cross described Nowell as "a man of great physical strength and hardihood." He went on to relate a story in which late autumn hikers descending by way of Valley Way found the ice broken in a pool along Snyder Brook. The trampers suspected that the ice had been broken by a bear but later learned from Nowell that it was he who had plunged into the stream that frosty morning for a refreshing dip.

BENJAMIN F. OSGOOD (1829–1907), for years, was head porter at the Glen House in Pinkham Notch and was well known as a mountain guide and path-builder. He was responsible for construction of the Osgood Trail, which in essence linked the Glen House with the summit of Mount Madison. The path was constructed in 1878. Three years later, he cut a trail from Osgood's Falls on the Mount Madison Path to Spaulding Lake in the Great Gulf.

On December 7, 1858, Osgood accompanied Lucius Hartshorn of Lancaster, a deputy sheriff in Coos County, on the first so-called winter ascent of Mount Washington. The purpose of the trip was to "make an attachment" of property at the summit in connection with ongoing litigation over a title dispute. They climbed via the unfinished

carriage road to the summit, thence "over the crust" to the summit. The men managed to enter one of the rime-coated summit houses through a window "on which the frost was a foot and a half in thickness."

"The interior of the hotel was like a tomb, the walls and all the furniture being draped with some four inches of frost, while the air was extremely biting, and the darkness was such that a lamp was necessary to enable them to distinguish objects," wrote historian Frederick Kilbourne. Osgood and Hartshorn fortunately managed to get down below the tree line just before poor weather settled in atop the mountain.

Osgood was born on June 7, 1829, to Benjamin F. Osgood and Mary Stickney of Fryeburg, Maine. After attending school and working on farms, he taught "writing schools in the winter." While affiliated with the Glen House, Osgood was an industrious entrepreneur. According to Nathaniel Tuckerman True in his *History of Gorham, New Hampshire*, Osgood "collected minerals among the mountains to sell to tourists, and also makes a large number of canes from the native woods among the mountains, which he sells to travellers. He sold 700 last summer." Gordon also worked for E. Clement & Company of Gorham as a log scaler. He married Charlotte Gordon of Gorham on March 16, 1868.

In an article appearing in the July 23, 1901 edition of the summit newspaper, *Among the Clouds*, Osgood recalled, "I began work for Major Gibbs at the Crawford House on June 1, 1856, but left there on July 22 and went to the Glen House, where I was hired and went to work 15 minutes after I arrived, and stayed 28 years."

Early trail construction in the Northern Presidentials led through some of the roughest, toughest terrain in New England, like that found in King Ravine on the northern slopes of Mount Adams. *Photo by Guy Shorey, courtesy Randolph Mountain Club.*

WILLIAM PEEK (1820–1905) summered in Randolph at the Ravine House for twenty-five years, beginning in 1879, and played an instrumental role in the development of the trails in the region and in early explorations of many White Mountain summits. In *Randolph: Old and New*, a history of the town written by George Cross and published in 1914, the author related the tale of a chance 1878 meeting of Peek and local innkeeper Laban Watson at the Gorham railroad station. This meeting, at which Watson invited Peek to stay at his family's farm, would ultimately result in Peek spending more than twenty-five summers at Watson's Ravine House.

Peek was born in London, England, in 1820 and was educated at Merton Abbey School. He arrived in America at eighteen years of age and in just a few years was a junior partner in the firm of Weeden and Peek, booksellers and publishers in Providence, Rhode Island. In 1853, he became a partner, and later sole proprietor, of a furniture manufactory in Chicago, Illinois. The business prospered almost from the start, and Peek, who owned what eventually proved to be valuable in-city property, was able to "retire early from business to a life of leisure," which included much reading and scientific experimentation, especially with plants. He was also an accomplished organist, playing for one of Chicago's churches, and painted in oils and water "with rare skill and taste." Many of his works, in fact, later adorned the walls of the Ravine House.

Following the death of his beloved wife in 1878, Peek vacationed in the White Mountains for the first time, then returned annually starting the following summer. There, he

William Peek summered in the Randolph area for a quarter of a century and frequently explored the mountains with Eugene Cook. *Randolph Mountain Club/Cook Archive.*

developed a close relationship with fellow mountain enthusiast Eugene B. Cook, with whom Peek shared many adventures in the Whites.

Besides exploring the mountains with Cook and helping to establish many new trails in the northern White Mountains, Cook seemed to enjoy coming up with fanciful names for his new paths and other local landmarks. Durand Ridge, Sylvan Way, Dell of the Fairy Spring and probably Devil's Hop Yard are among Peek's names still used today. Other colorful names, such as Chicago and Wabash Avenue and Peek-a-Boo Path, have disappeared over the years.

New trails that Peek helped build in the late 1800s and early 1900s included the above tree line section of the Airline along Durand Ridge, the lower section of the Howker Ridge Trail, the Ice Gulch Trail and the original Scar Trail. Peek had a special connection to the forested peaks north of present-day Route 2, including Mount Cabot and peaks of the Weeks Range, which he often explored.

JAMES STURGIS PRAY (1871–1929), a native of Boston and an 1898 graduate of Harvard University, made his mark on the White Mountain trail system as a longtime AMC member and the club's councillor of trails from 1902 to 1904. He is perhaps best known for his "scouting out" and then cutting a new trail linking the Swift River Valley (Albany) with the Waterville Valley region. This path, known as the Swift River Trail, ran from Shackford's (near Sabbaday Brook) up and over Kancamagus Pass and down to J.E. Henry's abandoned Hancock Branch logging railroad, where it linked up with the former trail from there to Greeley Ponds. It followed pretty much the path of today's Kancamagus Highway.

Pray is credited also with pushing for a more unified trail system in the Whites, one in which major centers of hiking activity would be linked by connecting trails, such as his Swift River Trail, which in effect linked the Sandwich Range paths with those of the Waterville Valley area.

Pray was a longtime acquaintance of Benton MacKaye, who would go on to conceive the idea of the Appalachian Trail. The two were schoolmates at Harvard when in August 1897 they paid a visit to the White Mountains. It was, MacKaye claimed in later years, the first time he "saw the true wilderness." Pray, MacKaye and a third companion, Draper Maury, had traveled by bicycle from Shirley, Massachusetts, to Albany Intervale the previous ten days and set off into the woods on August 14, their immediate objectives being Owl's Cliff and Mount Tremont near Livermore. Their trail-less ascent was a brutal one through acres and acres of blowdown. At

times, they had no choice but to crawl on their bellies to make it through the tangled mess. As they neared what they thought was the true summit of Tremont, a raging thunderstorm hit, and the trio narrowly missed being hit by a close lightning strike. During a brief letup in the storm, they managed to build a rough shelter, which they used to ride out another wave of storms and a long, wet night in the woods.

From Tremont, the three steered northward and climbed over Mounts Lowell and Anderson—the two peaks forming the east wall of Carrigain Notch—and then made their way to Crawford Notch and the Crawford House hotel. An attempt to reach Mount Washington via the Crawford Path failed due to heavy rains. Instead, the hikers, now joined by a fourth individual, Rob Mitchell, headed by train to Gorham, then took a stage along the Glen Road and tackled the mountain from the east (Pinkham Notch). Following a night's stay night atop Mount Washington's Summit House, the group traversed the southern Presidentials, returned to Crawford Notch, took a train to the height-of-land in Franconia Notch and from there traveled south to North Woodstock. They walked back to Albany Intervale by way of Mount Osceola and the Tripyramids.

MAJOR CURTIS BURRITT RAYMOND (1816–1893) was a lover of the White Mountains who constructed early trails on Mount Washington, in the Crawford Notch area and in North Conway.

Born and raised in Sherburne, New York, Raymond went on to attend the Rensselaer Polytechnic Institute and Columbia University before eventually settling in the Boston area. Well known in military circles, he attained the rank of major and during the early years of the Civil War drilled Union army regiments at a camp in Lynnfield, Massachusetts.

"Among the many persons interested in the scenery of the White Mountains region, Mr. Raymond proved himself to be pre-eminent for his knowledge and love of our Granite Hills," wrote artist Benjamin Champney in 1896.

> [Raymond] *had great interest in seeking out new points of view and opening them up for the benefit of others. He was a gentleman of wide culture and great experience as a mountain explorer. He had lived among the mountains of Pennsylvania, and was quite familiar with the scenery of Colorado and California. He had journeyed extensively in the Switzerland and Italian Alps, and was very cosmopolitan in his range of thoughts. But after his return from abroad his annual visits to our White Mountains*

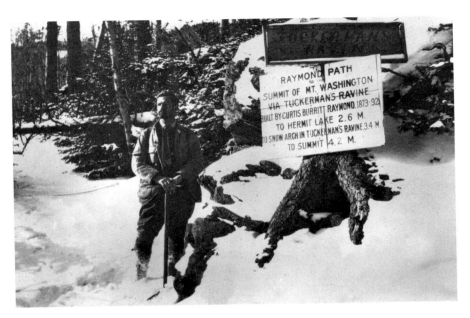

Karl Harrington sets off on the Raymond Path to Tuckerman Ravine in this undated photo. *Appalachian Mountain Club.*

and his most enthusiastic love for them, showed itself at all times, and he expressed himself most eloquently in regard to them.

Among his early White Mountain trail projects was the establishment of a permanent route between the Glen House and Tuckerman Ravine on the southeast slope of Mount Washington. This trail, long known as the Raymond Path, was first blazed by Raymond in 1863 but was not truly completed for another sixteen years, in 1879. Originally, the path began 2.3 miles up the Carriage Road, then went south across the base of Huntington Ravine and on to Hermit Lake. From there, it ascended Tuckerman Ravine as far as the famous Snow Arch, for a total a distance of 3.4 miles. After a newer, more direct trail to Hermit Lake was built from the site of the present-day AMC Pinkham Notch Camp, and a trail from the Snow Arch to the summit of Mount Washington was established, the Hermit Lake/Snow Arch section of Raymond's Path became part of the Tuckerman Ravine Trail. Today's Raymond Path has been shortened even further, starting now on the Old Jackson Road, 0.3 mi. south of the Auto Road.

Historian Frederick W. Kilbourne noted that Raymond made improvements to the path in 1891; after his death in 1893, it was maintained

by his widow, Lydia. After logging activity on the lower slopes of the mountain for all intents and purposes obliterated the northernmost mile of the path (i.e., the end nearest the carriage road), the path was reopened in 1904 with financial assistance from Mr. Raymond's widow, and maintenance was taken over by AMC.

Elsewhere in the Whites, Champney noted that Raymond "worked hard one season...planning and opening a new path to the summit of Middle Mountain [or Moat Mountain], where a marvelous panorama awaits the gaze of the tired climber. This path he selected with consummate skill, crossing the little streams with rustic bridges and showing points of interest at every turn."

Raymond also spent many summer at the Crawford House, where his enthusiasm for opening access routes to the walking public resulted in the building of an "agreeable and easy path to the Merrill Spring and Ammonoosuc Lake," both located just behind the grand hotel at the top of Crawford Notch. "This work he did in a thoroughly artistic manner. Taking nothing away that could not be spared and carrying along his path between the grand old trunks of the primeval forest without disturbing any of its beauty," wrote Champney.

DR. GEORGE A. SARGENT was an 1876 graduate of Harvard University who first came to the White Mountains and the Randolph area in about 1882 as medical student. According to *Randolph Old and New*, he was "engaged in the cotton business in the South, and interests in the West."

He has been described as a "muscular climber" of iron endurance, as was witnessed in his 1882 Presidential Range traverse with E.B. Cook (see earlier entry). Another epic adventure of Sargent's was his 1885 trail-less excursion from Randolph to Bunnell Notch in the Kilkennys by way of the Pond of Safety, Round Mountain, Willard Notch and Terrace Mountain. There, he met up with Mr. Cook and Mr. Peek, who had busted their way to Bunnell Notch from the Lancaster side of the Kilkennys.

Along with many of the regular Ravine House summer residents, Sargent was an able-bodied trail-builder, often working in tandem with the great path-makers of the region such as Cook and Peek. He later purchased the large Henry Rich farm in Randolph and for many years made this his summer retreat.

Among the paths Dr. Sargent helped develop were the Castle Trail up Mount Jefferson (1884); the Sargent Path, which led from his Randolph home up to Lookout Ledge; and Sylvan Way. One of his most ambitious

excursions, a traverse of the rugged and trail-less Dartmouth Range near Bretton Woods, is found in the December 1883 issue of *Appalachia*. This two-day September 1883 bushwhack over Mounts Deception, Dartmouth and Mitten also included Eugene Cook, A.S. Eddy, Albert Matthews and J.P. Clark, all of Boston, as well as local guide Charles E. Lowe.

Sargent's memory is preserved today in a rock outcropping high up on the side of Ice Gulch known as Sargent's Cliff.

WILLIAM M. SARGENT was from the North Woodstock area and was a well-known woodsman, guide, path-maker and "lover of the mountain fastnesses," wrote E.B. Cook He was frequently contracted by AMC to build trails in the Woodstock-Moosilauke area.

In 1880, he was hired to cut the eastern half of the trail connecting Thornton with the Mount Moosilauke area and Warren. In December 1884, he joined Cook in a traverse of the then trail-less peaks of Mounts Blue and Cushman near Moosilauke. Sargent also cut a new and improved path to Georgiana Falls and Harvard Cascades in the summer of 1884 and was described by Isabella Stone as "a skilled woodsmen and a faithful worker."

ALLEN THOMPSON (1814–1909), "Old Man" Thompson, wasn't a trail-builder but rather was one of the best-known and most competent mountain guides of the 1800s. A longtime Bethlehem resident (seventy-six years), he was a legendary trapper, hunter, fisherman and guide who knew the trackless western side of the mountains probably as well as anyone of his day.

In the "Echo Explorations" series of adventures published during the summers of 1979 and 1880 in the *White Mountain Echo and Tourist's Register*, it was Thompson who "guided" writer Benjamin A. MacDonald into the Zealand Valley, onto Garfield Ridge, into the Franconia Brook valley and up onto the Twin-Bond Range. For a more detailed look at Thompson, see the "Allen Thompson: Early White Mountain Guide" chapter.

KATE SLEEPER WALDEN (1862–1949), a native of the Boston area, settled in the Wonalancet region of Tamworth as a young woman and quickly established a reputation as a likeable and energetic innkeeper and outdoor enthusiast. Her efforts led to the creation of an intricate network of hiking paths on the Sandwich Range in the southern White Mountains.

Born to Charles F. Sleeper and Zilpha Thomas, Kate lost her mother at early age (ten) and frequently found herself visiting friends and relatives in the Tamworth area. It was during one of these visits, in 1890, that

she decided to buy an old farm in the Birch Intervale (later renamed Wonalancet) section of town and convert it to an inn. It was from the Wonalancet Farm that Sleeper became an integral member of her community and the founder of the Wonalancet Outdoor Club, which would be responsible over the next thirty years for the construction of more than seventy miles of local hiking trails.

Legend has it that the then unmarried Sleeper came up with the idea for the trail club after several prominent AMC members, including former club president Charles Fay, stayed at her inn during the summer of 1891. From that visit was planted the seed that soon led to the forming of the club and the eventual building of trails to all the major peaks in the Sandwich Range, including the four-thousand-foot summits of Mounts Passaconaway and Whiteface.

Sleeper, who in 1902 married her longtime partner, Arthur Walden, would later play a pivotal role in preserving a three-thousand-acre tract of forestland north of Wonalancet known as "the Bowl." It was because of her efforts that this glacial cirque, which was home to a large stand of old-growth timber, was added to the newly created White Mountain National Forest.

A number of landmarks in the Sandwich Range pay homage to her devotion to the region. These include the peaks of East and West Sleeper (both traversed by the Kate Sleeper Trail) and Mount Katherine, a minor summit to the south of the Sleepers Ridge. Her husband, founder of the famous Chinook kennels in Wonalancet, is also memorialized with the Walden Trail, which climbs to the summit of Mount Passaconaway.

LABAN MERRILL WATSON (1850–1936) was the longtime proprietor of the Ravine House in Randolph, which for years was the summertime home to many early AMC members. The Ravine House was built in the 1850s by Watson and his father, Abel, and originally operated as the Mount Madison House. In the spring of 1877, it was renamed the Ravine House and operated as an inn until 1960. (Watson himself sold the Ravine House in 1909 and retired to the Howker Farm at the mouth of Coldbrook, where he lived until his death. His home was for many years known as Coldbrook Lodge.)

Watson was an instrumental figure in the development of paths on the Northern Peaks of the Presidential Range. He is credited with building one of the earliest paths from Randolph to the summit of Mount Adams. The Watson Path was completed in 1882 after two year's effort by Watson and his father. He joined the AMC in 1878, and at the time of his death in 1936, there were just seventeen members who had belonged longer than he.

In 1885, Watson aided in the construction of the first path on Mount Adams's Durand Ridge, doing much of the axe work after Messieurs Cook, Peak and Sargent had blazed the a new connecting route directly up onto the ridge instead of connecting via Valley Way and the Snyder Brook valley. At this time, he also constructed Camp Placid (in 1885), a secret, short-lived camp or shelter located just off the Air Line near its junction with the older route onto the ridge.

Three years later, in 1888, Watson helped construct the Appalachian Mountain Club's new Madison Spring Hut in the col between Mounts Madison and Adams and at the head of Snyder Brook. Watson was responsible not just for the actual building of the stone structure but also for the construction of a "passable road" and the "transportation of the material" to the work site.

Longtime Randolph innkeeper and trail-builder Laban Watson helped construct one of the first paths up Mount Adams in 1881–82. *Mount Washington Observatory.*

According to George Cross in *Randolph: Old and New*, the Watsons' guests at Ravine House "always knew that their plans for the opening of new paths, the repairing of old ones, the clearing of view points, or the developing of beauty spots would be promptly carried out by the Watsons and their men."

Watson was born in Randolph on May 14, 1850, and died on October 1, 1936. The son of Abel N. Watson and Susan C. (Holmes) Watson, he was schooled in a tiny "block house" built by his uncle, John Watson. In 1873, Laban Watson married his stepsister, Anna Burbank, the daughter of his father's second wife, Cordelia (Wight) Burbank, who, like Abel Watson, was a widow. Laban Watson's wife predeceased him in 1912. The Watsons had six children—four sons and two daughters—two of whom died in infancy.

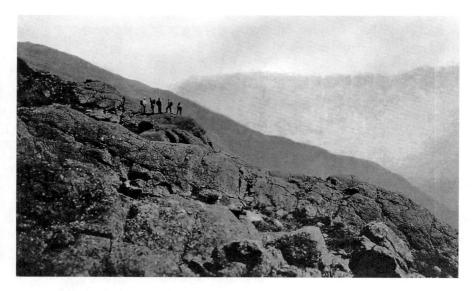

Ascending hikers along the Presidential Range enjoy wide-open views from this rocky stretch of trail. *David Govatski.*

Writing in the June 1937 edition of *Appalachia*, longtime AMC mapmaker and Randolph resident Louis F. Cutter said that Watson was "a kind friend and obliging host of all who sought his house" and an "eager and sympathetic helper of all in trouble or danger."

Cutter described the young Watson as being "tall and broad-shouldered, with muscle, endurance, and wit strengthened and tempered in the school of the farm and the logging camp, a lover of horses and fierce driver."

Bibliography

BOOKS

Andersen, Larry. *Benton MacKaye: Conservationist, Planner, and Creator of the Appalachian Trail*. Baltimore, MD: Johns Hopkins University Press, 2002.
Burt, F. Allen. *Story of Mount Washington*. Hanover, NH: Dartmouth Publications, 1960.
Carpenter, Frank O. *The Franconia Notch and Pemigewasset Valley*. Boston: Alexander Moore, 1898.
Child, Hamilton. *Gazetteer of Grafton County, New Hampshire, 1709–1886*. Syracuse, NY: Syracuse Journal Company, 1886.
Churchill, Elizabeth K. *Bethlehem and Its Surroundings*. Cambridge, MA: Riverside Press, 1876.
Connor, Daniel P. *Old Man Thompson: A White Mountain Story of Infinite Thought Value*. Manchester, NH, 1911.
Conrad, Justus. *The Town of Woodstock and Its Scenic Features*. Littleton, NH: Courier Printing Company, n.d.
Crawford, Lucy. *The History of the White Mountains: From the First Settlement of Upper Coos and Pequaket*. Portland, ME: B. Thurston & Company, 1886.
Cross, George N. *Randolph: Old and New*. Boston: Town of Randolph, New Hampshire, 1924.
Draves, David D. *Builder of Men: Life in C.C.C. Camps in New Hampshire*. Portsmouth, NH: Peter Randall Publishing, 1992.

Bibliography

English, Jane, and Ben English Jr. *Our Mountain Trips, Part II: 1909–1926*. Littleton, NH: Bondcliff Books, 2007.

Gosselin, Guy A., and Susan B. Hawkins. *Among the White Hills: The Life and Times of Guy L. Shorey*. Portsmouth, NH: Peter E. Randall Publisher, 1998.

Gove, Bill. *Logging Railroads Along the Pemigewasset River*. Littleton, NH: Bondcliff Books, 2006.

Harkness, Marjory Gane. *The Tamworth Narrative*. Freeport, ME: Bond Wheelwright Company, 1958.

Harrington, Karl P. *Walks and Climbs in the White Mountains*. New Haven, CT: Yale University Press, 1926.

Hooke, David O. *Reaching that Peak: 75 Years of the Dartmouth Outing Club*. Canaan, NH: Phoenix Publishing, 1987.

Hudson, Judith Maddock. *Peaks and Paths: A Century of the Randolph Mountain Club*. Randolph, NH: Randolph Mountain Club, 2010.

Hudson, Judith Maddock, ed. *Two Notebooks of Charles E. Lowe*. Randolph, NH, 2007.

Jackson, Charles T. *Final Report on the Geology and Mineralogy of the State of New Hampshire*. Concord, NH: Carol & Baker, 1844.

Joslin, Richard S. *Sylvester Marsh and the Cog Railway*. Mount Washington, NH: Mount Washington Cog Railway, 2000.

Kilbourne, Frederick W. *Chronicles of the White Mountains*. Boston: Houghton Mifflin Company, 1916.

King, Thomas Starr. *The White Hills: Their Legends, Landscape, and Poetry*. Boston: Isaac N. Andrews, 1859.

May, Samuel J. *Life of Samuel Joseph May*. Boston: Roberts Brothers, 1873.

McPhaul, Meghan McCarthy. *A History of Cannon Mountain: Trails, Tales and Skiing Legends*. Charleston, SC: The History Press, 2011.

North Woodstock Improvement Association. *A Littler Pathfinder to Places of Interest Near North Woodstock, New Hampshire*. 3rd ed. North Woodstock, NH, 1914.

Pease, Arthur Stanley. *Sequestered Vales of Life*. Cambridge, MA: Harvard University Press, 1946.

Perry, A. Bernard. *Albany's Recollections*. Albany, NH, 1976.

Potter, Mabel Harrington, ed. *Karl Pomeroy Harrington: An Autobiography*. Boston: Thomas Todd Company, 1975.

Randolph Mountain Club. *Randolph Path*. 8th ed. Randolph, NH, 2005.

Roberts, Reverend Guy. *Lost River and Going Through It*. 12th ed. Whitefield, NH, 1942.

Bibliography

Rowan, Peter, and June Hammond, eds. *Mountain Summers: Tales of Hiking and Exploration in the White Mountains from 1876 to 1886 as Seen Through the Eyes of Woman*. Gorham, NH: Gulfside Press, 1995.

Smith, Steven D. *Mount Chocorua: A Guide and History*. Littleton, NH: Bondcliff Books, 2006.

———. *Ponds and Lakes of the White Mountains*. 2nd ed. Woodstock, VT: Backcountry Publications, 1998.

———. *Wandering through the White Mountains*. Littleton, NH: Bondcliff Books, 2004.

Smith, Steven D., and Mike Dickerman. *The 4000-Footers of the White Mountains*. 2nd ed. Littleton, NH: Bondcliff Books, 2008.

———. *White Mountain Guide*. 29th ed. Boston: Appalachian Mountain Club Books, 2012.

Sweetser, Moses F. *The White Mountains: A Handbook for Travellers*. Cambridge, MA: Riverside Press, 1980.

Tolles, Bryant F., Jr. *The Grand Resort Hotels of the White Mountains*. Boston: David R. Godine, 1998.

Towne, Ruth W., and Chris M. Jerome. *Looking Back at Easton*. Easton, NH, 1976.

Waterman, Guy. *An Outline of Trail Development in the White Mountains, 1840–1980*. Randolph, NH: Randolph Mountain Club, 2005.

Waterman, Laura, and Guy Waterman. *Forest and Crag: A History of Hiking, Trail Blazing, and Adventure in the Northeast Mountains*. Boston: Appalachian Mountain Club, 1989.

Wight, D.B. *The Androscoggin River Valley: Gateway to the White Mountains*. Rutland, VT: Charles E. Tuttle Company, 1967.

Wonalancet Outdoor Club. *Guide to Wonalancet and the Sandwich Range of New Hampshire*. Replica ed. Littleton, NH: Bondcliff Books, 2002.

Wroth, Katharine, ed. *White Mountain Guide: A Centennial Retrospective*. Boston: Appalachian Mountain Club, 2007.

Periodicals and Journals

Appalachia
Among the Clouds
Granite Monthly
The Littleton Courier
White Mountain Echo and Tourist's Register

Index

A

Adams, Sherman 85
Adams Slide Trail 118
Agassiz, Louis 52
Alden, Edmund 65
Alpine Garden Trail 118
Ammonoosuc Ravine 103
Appalachian Mountain Club 15, 25, 45, 54, 57, 65, 69, 84, 90, 96, 103, 105, 108, 109, 115, 131

B

Baker, Eben 46
Barron Mountain 73
Beaver Brook Trail 84
Beaver Meadow 77
Belcher, C. Francis 82
Bellows, John 31
Benton Trail 35, 88
Bickford, Frank 85
Blood, Charles W. 96, 98, 114
Boothman, John, Jr. 121
Brown, J. Wilcox 83
Bunnell Notch 128

C

Cabin-Cascades Trail 91
Cain, George 85
Cannon Mountain 25, 34, 68, 85, 88
Caps Ridge Trail 111
Carpenter, Frank 104
Carpenter, Frank O. 34, 65, 66, 70, 78, 104
Carrigain Notch 69, 126
Carter-Moriah Trail 91
Carter Notch 91
Cascade Camp 111
Cascade Ravine 91, 109, 111
Castle Ravine 111, 121
Castle Trail 128
Central Gully 99
Challon, John 48
Champney, Benjamin 28, 126
Chandler Brook Trail 118
Chatham Trails Association 65
Chocorua Mountain Club 65
Churchill, Elizabeth 54
Civilian Conservation Corps 86
Clark, Franklin P. 104
Conn, Herbert W. 65
Cook, Edith Walker 107
Cook, Eugene B. 125

INDEX

Cook, Eugene Beauharnais 105
Cook Path 91
Coolidge, Joseph 17
Coppermine Ski Trail 88
Crawford, Abel 11, 13, 14, 17, 21, 23, 28, 44, 45, 46, 51, 95
Crawford, Allen Crawford 95
Crawford Bridle Path 47
Crawford, Ethan Allen 11, 13, 14, 16, 19, 20, 37, 43
Crawford House 22, 27, 62, 63, 107, 108, 123, 126, 128
Crawford, Lucy 11, 15, 17
Crawford Notch 11, 14, 17, 19, 20, 21, 27, 43, 44, 61, 69, 91, 95, 107, 110, 118, 119, 126, 128
Crawford Path 17, 19, 28, 32, 37, 38, 41, 43, 44, 46, 47, 48, 69, 112, 126
Crawford, Thomas 27
Crawford, Thomas J. 44
Culhane, Thomas 107
Cushing, Caleb 17
Cutter, Louis Fairweather 108, 109

D

Dartmouth Outing Club (DOC) 84
Davis, Nathaniel T.P. 21
Davis Path 22, 28, 48, 118
Dodge, Joe 114

E

Eagle Lakes 26
Eagle Pass 25
Eames, Blanche K. 47
Edmands Col 111
Edmands, John Rayner 51, 91, 107, 109, 121
Elbow Pond 82
Eliza Brook 69
Emerald Ridge 111
Emerson, George B. 17
Ethan Pond 57, 61, 69
Evans, Jonathan Ray 114

F

Fabyan Bridle Path 21, 39, 40, 47, 112
Fabyan, Horace 21, 28, 29, 38, 39, 40
Fay, Charles 91, 130
Field, Darby 12
Fisher, Colonel Horace 72
Flume House 34
Franconia Falls 73
Franconia Notch 25, 27, 33, 34, 66, 67, 69, 70, 75, 80, 84, 104, 105, 126

G

Garfield Ridge Trail 98, 104, 119
Georgiana Falls 34, 129
Gibb, Joseph Lane 25
Gibb, Stephen C. 25
Gibbs, Colonel George 15
Glen Boulder Path 48
Glen Bridle Path 32
Glencliff Trail 28
Glen House 31, 32, 49, 69, 91, 107, 108, 122, 123, 127
Goodrich, Arthur L. 95, 96, 98, 114
Goodrich, Nathaniel Lewis 95, 98, 100, 103, 114, 118
Goodrich Rock 96
Gordon, James 115
Gordon Pond Railroad 82
Gorges, Thomas 12
Gorham House 30
Gove, Bill 83
Great Gulf 118, 122
Greenleaf Trail 25
Griggs, Leland 84
Gulfside Trail 111, 112

H

Hall, Joseph S. 20, 32
Harrington, Karl Pomeroy 65, 67, 72, 82, 115
Harrington Pond 69
Hartshorn, Lucius 122
Hart's Location 14, 15, 22

INDEX

Hart, Warren 115
Henry, James Everell 57, 63, 69
Hitchcock, John 30, 35, 107
Hubbard Gorge 73
Hunt, Hubbard 111, 118, 121
Hunt, Wilbur 80

J

Jackman, Charles 78
Jackman, Lyman 77, 78
Jackman, Royal 77, 78, 80
Jackson, Charles T. 21, 45
Jenk, Paul Rockwell 96, 98, 103, 114, 118
Johnson, George L. 81

K

Kettles Path 96
King Ravine 91, 109, 115
Kinsman, Nathan 75
Kinsman Notch 75, 77, 80, 81, 83, 84, 85, 86, 87, 88
Kinsman Ridge Trail 85, 98
Knight, Samuel 27

L

Lafayette House 27, 33
Lakes of the Clouds 12, 18, 45, 48, 104
Little Haystack 104
Little, Jesse 34
Little, Susan 34
Littleton Riding Club 47
Little, William 28, 29
Log Cabin 91
Lookout Ledge 128
Loon Pond Mountain 74
Lost River 75, 77, 78, 80, 81, 82, 83, 84, 85, 86, 87, 105
Lowe, Charles E. 89, 120, 129
Lowe, Clovis 89
Lowe, Levi 89
Lowe, Thaddeus 120
Lowe, Vyron 120
Lunderville, Doris 48

M

MacDonald, Benjamin A. 53, 57, 129
Mahoosuc Range Trail 69
Martin, Dora 83
May, Samuel Joseph 17
McCrillis Path 36
McCrillis, William 36
McGraw, James E. ("Jakey") 83
Mill Brook Cascades 73
Moat Mountain 35, 128
Moody, Joseph 17
Moran (or Lonesome) Lake 72
Mount Adams 89, 90, 91, 93, 109, 111, 120, 130, 131
Mount Anderson 126
Mount Blue 83
Mount Bond 69
Mount Caribou 107
Mount Carr 67
Mount Chocorua 35, 69
Mount Cilley 73, 82
Mount Clay 32, 101
Mount Clinton 44, 45, 47, 48, 107
Mount Crawford House 22
Mount Crescent House 93
Mount Cushman 82, 129
Mount Deception 129
Mount Eisenhower 28
Mount Flume 67, 73
Mount Guyot 101
Mount Hale 107
Mount Jackson 21, 119
Mount Jefferson 111, 128
Mount Katherine 130
Mount Lafayette 25, 27, 33, 66, 70
Mount Langdon 107
Mount Liberty 34, 67, 104
Mount Lincoln 67
Mount Lowell 126
Mount Madison 93, 107, 118, 122
Mount Monroe 18, 45
Mount Moosilauke 27, 34, 72, 75, 81, 84, 85, 88, 129
Mount Moriah 35

INDEX

Mount Nancy 107
Mount Osceola 96, 105, 126
Mount Parker 107
Mount Passaconaway 130
Mount Pemigewasset 34, 73
Mount Pierce 11
Mount Pleasant 12, 28, 45, 48, 112
Mount Pleasant Path 28
Mount Pliny 107
Mount Royce 107
Mount Surprise 35
Mount Tecumseh 96, 101
Mount Tremont 125
Mount Tripyramid 126
Mount Washington 11, 12, 15, 17, 19, 20, 21, 28, 32, 35, 37, 40, 43, 45, 47, 68, 100, 101, 108, 111, 118, 122, 126, 127
Mount Washington Carriage Road 32, 47
Mount Washington Cog Railway 19, 37, 40, 43, 47, 49, 100
Mount Whiteface 36
Mount Willard 21, 22, 28
Mount Willey 61, 91

N

Nancy Pond Trail 103
Ness, Elmer 48
Nineteen-Mile Brook 32, 91
North Woodstock Improvement Association 65, 66, 70, 104
Notch House 20, 21, 22, 44, 45
Nowell Ridge 90, 91, 120, 121
Nowell, William Gray 90, 91, 120, 121

O

Old Bridle Path 33, 66, 67
Osgood, Benjamin F. 108, 122, 123
Owl's Cliff 125

P

Partridge, Alden 19
Pease, Arthur Stanley 110, 114

Peek, William 107, 124, 128
Perkins, Nathan 32
Pickering, William 47
Pinkham Notch 19, 28, 32, 47, 49, 51, 69, 91, 107, 122, 126, 127
Pond of Safety 128
Pray, James Sturgis 125
Profile House 27, 33, 34, 68, 73, 104
Prospect House 35
Publishers Paper Company 81
Pychowska, Martha Marian 107

R

Randolph Mountain Club 65, 108, 119, 121
Ravine House 103, 105, 107, 109, 111, 124, 128, 130, 131
Ravine Path 96
Raymond, Curtis B. 32, 126
Raymond Path 32, 127
Rollins, Edward 84
Rollins, Frank W. 84
Rosebrook, Eleazar 14
Rosebrook, Lucius 32
Round Mountain 128
Russell, Ernest 82
Russell Mountain 67
Russell, W.S.C. 78

S

Sandwich Mountain 96
Sargent, George 107, 128
Sargent Path 128
Sargent, William M. 129
Scar Trail 96
Sewall, Samuel E. 17
Shattuck, George 15
Shoal Pond Trail 69
Six Husbands Trail 118
Smith, Elisha 72
Society for the Protection of New Hampshire 83
Spencer Trail 75
Star Lake Trail 118

INDEX

Stillings, John 32
Stillings Path 32
Stone, Isabella 91
Summit House (Mount Moosilauke) 35
Summit House (Mount Washington) 48, 126
Sweetser, Moses F. 16, 36, 91
Swift River Trail 125

T

Table Rock 68
Taft, Richard 27
Teague, Henry 49
Terrace Mountain 128
Thompson, Allen 129
Thompson Falls (North Conway) 28
Thompson Falls (Pinkham Notch) 32
Thompson, Joseph Mariner 31
Thompson's Path 32
Thoreau Falls 57, 61, 62, 69
Thorndike, S.H. 111
Thornton Gore 74
Tip-Top House (Mount Moosilauke) 35
Tip-Top House (Mount Washington) 20, 69, 107
Tuckerman Ravine 16, 127
Tunnel Brook Trail 88
Twin Range Trail 98

V

Vines, Richard 12

W

Walden, Arthur 114
Walden, Kate Sleeper 129
Walden Trail 130
Ware, William 17
Waterman, Guy 28, 66, 90, 107
Waterman, Laura 66, 90, 107
Waterville Valley 95, 98, 103, 114, 125
Waterville Valley Athletic and Improvement Society 65
Watson, Laban 51, 118, 124, 130, 131

Webster Cliff Trail 98, 104, 119
Westside Trail 112
Whitcher, Chase 27
White Mountain Station House 30
Wildcat Ridge Trails 104
Wildwood Camp (CCC) 86
Willard Notch 128
Williams, Moses B. 46
Wonalancet Outdoor Club 65
Woodbury, Elmer 78
Woodstock Improvement Association 115

Z

Zealand Notch 57, 59

About the Author

Mike Dickerman is a longtime northern New Hampshire resident who was lured to the White Mountains region by its many foot trails, magnificent summits and lush valleys. After more than a decade of reporting on area events for the *Littleton Courier* newspaper, he started his own publishing company (Bondcliff Books) in 1996 and regularly writes, publishes and distributes books related to New Hampshire's North Country and White Mountains. For more than twenty-five years, his popular hiking column, "The Beaten Path," has appeared regularly in newspapers across the Granite State. He has authored or edited numerous books, including *The 4000-Footers of the White Mountains*, *Along the Beaten Path*, *Mount Washington: Narratives and Perspectives* and *Lincoln & Woodstock, New Hampshire*. He was also co-editor of the award-winning anthology *Beyond the Notches: Stories of Place in New Hampshire's North Country* and served as co-editor of the twenty-ninth edition of the *AMC White Mountain Guide*. He lives in Littleton, New Hampshire, with his wife, Jeanne.

Visit us at
www.historypress.net

This title is also available as an e-book.